Black & White LANDSCAPE PHOTOGRAPHY

John Collett and David Collett

AMHERST MEDIA, INC. ■ BUFFALO, NY

for Mom and Dad,
who taught us how to see

Acknowledgements:

We would like to extend our warmest appreciation first and foremost to Miguel Candelaria, whose help was invaluable. His objective conceptual and textual comments helped to define as well as refine this book. As we moved closer to the publication deadline, Miguel's unselfish contributions made all the difference. We would also like to thank Craig Alesse and Michelle Perkins of Amherst Media, Inc., who were patient and helpful throughout the book's conception and production. Finally, throughout this project, we diverted much time and attention from our families and closest friends. We sincerely appreciate their patience, understanding, and great support.

Published by:
Amherst Media, Inc.
P.O. Box 586
Buffalo, N.Y. 14226
Fax: 716-874-4508

Publisher: Craig Alesse
Senior Editor/Project Manager: Michelle Perkins
Assistant Editor: Matthew A. Kreib
Editorial Consultant: Dan Schwartz, J.D., Ph.D.

ISBN: 1-58428-004-2
Library of Congress Card Catalog Number: 99-72179

Printed in the United States of America.
10 9 8 7 6 5 4 3 2 1

TABLE OF CONTENTS

INTRODUCTION

Landscape photography is, in many respects, very different from other types of photography. In studio, portraiture, advertising, editorial, scientific, and even some architectural photography, the photographer can usually control elements in the scene. These elements include the relative position of objects, the background, the foreground, the lighting position and quality, and the color or black-and-white tonal range of the scene.

Conversely, when photographing landscapes, you are at the mercy of these elements – quickly changing weather, changing and uneven illumination, poor contrast or limited tonal range, undesirable yet unchangeable foregrounds or backgrounds, and extraneous objects in the scene which may significantly detract from your composition. Your challenge as a fine-art landscape photographer is to turn these liabilities into assets, to highlight nature's diverse range of natural composition, and to reveal the simple, underlying beauty of the landscape.

Before we take you into the field to capture the great outdoors on film, we cover what type of equipment is ideal for landscape photography. You will learn which equipment is best suited to your goals and budget. Keeping you indoors a little while longer, Section Two explores the subjectivity in the definition of art, the intentional manipulation of reality, types of landscape photography, and the important balance between creativity and technique. By then, you will be ready to step outside where, in Section Three, we hope to expand your vision. You will see the landscape in terms of nature's intricate organization, simple designs, and rich palette of tonalities and light. With this foundation in composition, Section Four concentrates on the significance and techniques of focus and controlling tonalities in b&w images. Understanding the role of the darkroom process follows in Section Five, along with suggestions on how to frame, display, and even sell your images. Finally, in Section Six, we provide five images with point-by-point analyses covering composition, field, and darkroom techniques.

"Your challenge as a fine-art landscape photographer is to turn liabilities into assets ..."

"... emerge as a more confident, artistically mature, and technically savvy photographer."

We assume that you are already familiar with camera and film basics and terminology. This book will build on your existing knowledge of photography and take you to the next plateau of creating beautiful, fine-art b&w landscape images.

Our hope is that this book, as well as the actual landscapes you visit, will inspire you as much as it has renewed our own inspirations. We also hope that after reading our book, critically analyzing the landscape and your own images, and looking deeply within yourself for the artist, you will emerge as a more confident, artistically mature, and technically savvy photographer. Good luck!

THE ARTIST'S TOOLS

Unlike other disciplines of photography, landscape photography offers unique challenges. First, the landscape photographer has little or no direct control over the elements in the scene. You cannot tilt the mountain range slightly to the left. You cannot physically darken the clouds or give the stream softer lines. One of your challenges, then, is to control and even enhance nature's elements visually.

Second, unlike most other types of photography, nature dictates the lighting, colors, contrast, and weather. Each of these can change from hour to hour, sometimes from minute to minute. A landscape photographer has the distinct challenge to compensate for these unpredictable changes, and even take advantage of them for a unique, dramatic shot.

Third, as a landscape photographer, you should strive to produce photographs that render nature as beautifully and technically perfect as possible. Your challenge is to create a final print that

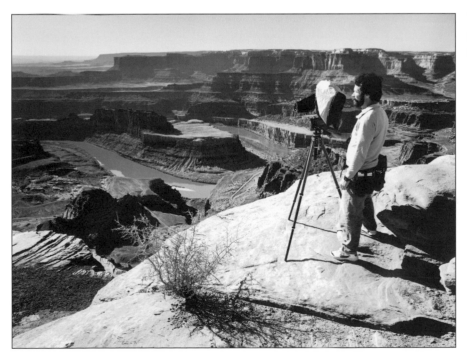

Through technique, experience, and imagination, the landscape photographer creates a personal vision of the land.

"... your first step should be a careful selection of the tools of the trade."

has the same huge depth of field, panoramic scope, incredibly fine detail, wide contrast range, and overall drama as the original scene. If you can meet this challenge, you have not only produced a work of art, but have also, in a sense, preserved nature itself.

Before you run out with your camera to conquer nature, however, your first step should be a careful selection of the tools of the trade. Your correct choice of equipment is important toward achieving these three challenges. The choices of cameras, lenses, filters, and accessories are immense and can be confusing. Fortunately, these choices can be narrowed down to only that equipment best suited for photographing landscapes.

Whether you aspire to become a professional landscape photographer or simply to improve your occasional shot, the cost of equipment is usually a factor. You probably already own a camera and one or two lenses. These may or may not be adequate for landscape photography, depending on your goals. If you decide to purchase a new (or used) system, you need to match your photographic needs with the appropriate tools at a price you can afford.

If you talk to ten landscape photographers, each one will give you a slightly different list of what you should buy. Just as different painters use different types of brushes to achieve their own style, photographers each use different combinations of cameras, lenses, and filters. Although budget is usually one of the important factors in considering which format and accessories to purchase, it should not be the only consideration. Section 1.1 highlights the advantages and disadvantages of each camera format.

Section 1.1
CAMERA FORMATS

The most important aspects of landscape photography are visualizing the landscape, composing the scene, and recording onto film the beauty of the original scene. To this end, choosing the right camera size should be secondary to learning the craft of fine photography. Many photographers have created dramatic landscape images using only inexpensive cameras; conversely, others have spent fortunes on the best equipment, yet have never taken that award-winning shot.

Each format size carries with it inherent advantages and disadvantages. Your initial step should be to evaluate your own needs and photographic goals at your current level of experience. Correctly matching the tools to your needs should be your first, very important step to taking great landscape photographs.

Several issues are important to consider before buying a camera system. Do you hope to sell your prints professionally? Will you be printing only 8x10s, or do you want to print 11x14, 16x20, 20x24, or even larger? Would you rather have a camera

Recommended Landscape Photography Systems		
Small Budget ~($1000-$2000)	Medium Budget ~($2500-$3500)	Large Budget ~($3000-$5000)

Camera Format	35mm	6x7cm	4x5in
Lens purchase order:			
1st Purchase	Wide-angle (less than 35mm)	Normal (90mm-100mm)	Normal (150-180mm)
2nd Purchase	Normal (44-58mm)	Wide-angle (less than 65mm)	Wide-angle (less than 120mm)
3rd Purchase	Telephoto (greater than 135mm)	Telephoto (greater than 140mm)	Telephoto (greater than 240mm)
Filter Set (Minimum)			
#16 Medium Orange	✓	✓	✓
#8 Light Yellow	✓	✓	✓
#25 Red	✓	✓	✓
Polarizer	✓	✓	✓
#58 Green	✓	✓	✓
Neutral Density	✓	✓	✓
#21 Light Red		✓	✓
#12 Medium Yellow		✓	✓
Essential Accessories			
Extra batteries	✓	✓	✓
Tripod	✓	✓	✓
Camera bag	✓	✓	✓
Shutter release	✓	✓	✓
Film holders			✓
1° spot meter			✓
Dark cloth			✓
Focusing loupe			✓
Useful Accessories			
Changing bag	✓	✓	
Film changing tent			✓
Tool kit	✓	✓	✓

that has automatic exposure and focusing, or would you prefer to have the control of a completely manual camera? Do you want the ability to fine-tune the perspective and depth of field? Would you like the flexibility of tailoring the exposure and development times and processes for every negative?

If you are just beginning in photography, a small 35mm camera may be your best choice. Lightweight, partially or fully automatic, and inexpensive, it would allow you to concentrate all your efforts on composition rather than on the mechanics of a larger format. As your photographic skills progress, you may want to move up to a larger format camera in order to obtain larger negatives and achieve certain effects and quality that are difficult or impossible with a 35mm camera. The tables on pages 10 and 11 highlight the most important differences among the small, medium, and large format cameras.

This table will give you an overall good starting point for three different budget ranges. Within each budget, ✓ denotes the recommended equipment to purchase. As your budget, skill, and needs increase, you can add more accessories or move up to a larger format. These price ranges are based on the average cost of new equipment.

Small Format

The 35mm camera is certainly the most popular among the small formats for general-purpose photography. If you plan to hike long distances to shoot your landscape photos, the compact size, lightweight, and portability of the 35mm is ideal. Because of its size and popularity, the 35mm is the least expensive of the three formats. Unfortunately, due to its very small negative size, enlargements greater than about 8x10 inches will suffer reduced image sharpness and resolution with increased grain.

Medium Format

The medium-format camera addresses some of the disadvantages inherent in the small-format camera. Models are available to use negative sizes of 6x6, 6x7, 6x9, 6x12, or 6x17cm. These larger negatives offer greater image sharpness and resolution than the 35mm camera. Additionally, many medium-format cameras have removable film backs, enabling you to use different film types for different shots. The most important disadvantages with this format are its somewhat heavier frame, reduced portability, and higher cost. However, the medium format remains a popular choice for landscape photography.

Large Format

For the best image quality and composition flexibility, the large-format camera, also called the view camera, is the clear winner for landscape photography. The most common negative sizes are 4x5, 5x7, 8x10, and 11x14 inches. Having a significantly larger negative, this format offers the greatest image resolution and enlargement potential of any format. For example, large-format cameras employ single sheets of film, allowing you to expose and develop each image individually in order to control image contrast using the Zone System (Section 4.3). Additionally, the large-format cameras allow the lens and film planes to move

> "... the medium format remains a popular choice for landscape photography."

35mm		
Advantages		
• Easy to use • Size, weight, portability • Lower cost		
Disadvantages		
• Large prints lose sharpness and increase grain • Must develop all negatives identically • Lack of complete camera movements		

Medium Format		
Advantages		
• Enlarged prints retain sharpness • Size, weight portability • Removable film backs		
Disadvantages		
• Higher cost • Must develop all negatives identically • Lack of complete camera movements		

Large Format		
Advantages		
• Enlarged prints retain sharpness and fine grain • Expose and develop individual negatives • Full range of camera and bellows movements		
Disadvantages		
• Higher cost • More difficult to use • Size, weight, portability		

Criteria	Small (35mm)	Medium (6x7cm)	Large (4x5in)
Camera Format			
Beginning photographer	+	+	
Ease of use	+	+	
Purchase cost	+		
Size and weight	+		
Automatic exposure metering	+	+	
Portability	+	+	
Accessories available	+	+	+
Film choices / availability	+	+	+
Automatic focusing	+		
Viewer size		+	+
Big print enlargements Sharpest image Maximum resolution Minimum grain size		+	+
Ability to tailor development times for individual negatives			+
Lens-plane and film-plane movements for depth of field and perspective control			+
Contact printing		+	+
Repair locations	+	+	

No single format is perfect for every situation. This table shows which format is best-suited (+) for your criteria.

Terms to Know

Sharpness

Whereas resolution and grain are measurable, sharpness is more subjective. In the simplest terms, a photograph appears sharp if the viewer cannot detect a great degree of fuzziness. Absolute sharpness, of course, does not exist because even the "sharpest" negative or print will become unsharp through enough magnifications.

Several primary factors control the overall, apparent sharpness of the final print: focus and lens quality, depth-of-field, the degree of apparent motion in an object, grain size, and the resolution of the lens and film.

Resolution and Resolving Power

Resolving power is the ability of a lens or film to reproduce fine detail accurately. To determine the resolution, manufacturers measure how close together parallel lines can be spaced and still be visually separable.

Grain

Technically, grain refers to clumps of silver particles on the film created during the exposure and development processes. Visually, a photograph appears grainy if a viewer can easily detect these separate grains. The effect of grain on the final print is similar to a sandy texture. The plain, mid-tone areas of a print usually show the grain more than lighter or darker areas, or areas in which the gray tones vary considerably.

Generally, as the size of an enlargement increases, the space between the grains of silver increases. Some photographers attempt to minimize the apparent grain, whereas others try to maximize its effects in order to exaggerate or capture a certain mood in a landscape. The key factors contributing to the size of grain are the film, the film developer, the development temperature and time, the degree of magnification, and the overall tonality and contrast range of the print.

"... a 4x5 camera is your best choice."

independently, giving you greater depth of field and perspective control. These cameras also accept reducing backs and Polaroid backs, greatly extending the types of film you can use. Undoubtedly, the most significant drawbacks of the large format camera are its increased size and weight, reduced portability, and higher cost. If you are serious about creating landscape photographs of the highest quality, and if your budget allows, a 4x5 camera is your best choice.

Used Cameras

Careful inquiry at a reputable camera store dealing in used cameras should reward you with a camera that fits your needs and budget requirements. The following list highlights several points to consider when purchasing a used camera.

EXPOSURE METER

Many of today's small and medium format cameras have sophisticated internal exposure metering systems. Make sure that they are calibrated and accurate. Consider purchasing a camera that includes a built-in spot meter in addition to the standard averaging or center-weighted meters.

DAMAGE TO THE CAMERA BODY

Insure that any nicks and scratches to the camera body are merely cosmetic and do not affect any moving parts.

MOVING PARTS

Insure that all moving parts operate freely and smoothly. This is especially true for film advancing and rewinding as well as the shutter mechanism.

WARRANTY

Carefully review the warranty policy with the dealer. Many times the dealer or manufacturer may offer only a limited warranty or none at all.

Cost

Whether you decide to purchase a new or used camera, the cost is somewhat dependent on several factors: format size, degree of automation, and materials. In most cases, the cost increases with format size. Many of today's cameras are made of lightweight materials such as plastics and composites. These materials are durable, strong, and inexpensive. For large-format cameras, these lighter materials usually increase the cost because they help to decrease the weight, an advantage when carrying the camera over long distances. Purchase a camera from a well-known and respected manufacturer. The competition is fierce among the manufacturers, making it easy to obtain excellent prices.

Section 1.2
LENSES
Focal Length

The focal length of a lens is directly related to how large or how small the image appears. Lenses fall into three classes of focal lengths: wide-angle, normal, and telephoto. A wide-angle lens "pushes" the scene farther away, allowing the camera to "see" more of the landscape. Conversely, a telephoto lens enlarges distant objects, similar in function to a telescope. A normal lens views a scene with approximately the same perspective as that of a single human eye.

Landscape photographers usually prefer wide-angle lenses in order to capture as much of the panoramic view as possible. Sometimes, however, you may want to use a normal or telephoto lens for a closer, more compressed view of the scene. To determine what the focal lengths actually are for a wide-angle, normal, or telephoto lens, you need to look at the film format you will be using. As the film format increases, the lens class decreases. For example, a 150mm lens is considered a telephoto lens for a small-format camera but is close to a normal lens for a large-format camera.

Zoom lenses, or variable focal-length lenses, offer a continuous range of focal lengths within a single lens. For example, with a small-format 35mm camera, instead of purchasing a 70mm lens, a 135mm lens, and a 210mm lens, you could instead purchase a single 70–210mm zoom lens. Many other focal length ranges are available. In the past, the quality of zoom lenses was inferior to that of fixed focal-length lenses. Today's modern optics research and advanced manufacturing processes produce zoom lenses whose quality rivals the best-made fixed lenses. Purchasing a single zoom lens offers the advantages of lower costs and having less to carry in the field. Unfortunately, to date, zoom lenses for large-format cameras are unavailable.

Focal Length Name Equivalents

- Short = wide angle
- Medium (or standard) = normal
- Long = telephoto

Film Formats	Lens Class		
	Wide-angle	**Normal**	**Telephoto**
Small (35mm)	Less than 35mm	44-58mm	Greater than 135mm
Medium (6x7cm)	Less than 65mm	90-100mm	Greater than 140mm
Large (4x5in)	Less than 120mm	150-180mm	Greater than 240mm
	Most Landscapes		

This table shows a rough comparison of focal lengths for three specific film formats and lens classes. The shaded boxes represent the approximate focal lengths preferred for taking landscape photographs.

"... the most important consideration should be the quality of the optics and mechanics ..."

Used Lenses

If you decide to purchase a used lens, the most important consideration should be the quality of the optics and mechanics, followed by the warranty, and finally the price. If possible, always see the lens in person and test it on your camera before purchasing it. Carefully review the reputation and return policies of various dealers before buying a lens. The following guidelines will help you in making a wise purchase.

CHECK FOR MULTICOATING

Today's lenses have multiple coatings to improve contrast, color saturation, and light transmission. These coatings reduce or eliminate distortion, ghost images, and lens flare.

MECHANICS

Check that all the mechanical parts operate smoothly. Be sure that every moving part, such as the aperture and focusing ring, works quietly and smoothly.

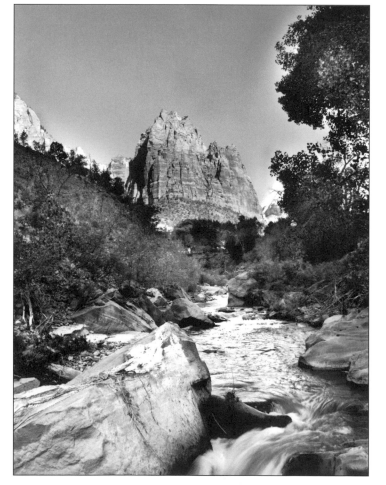

Wide-angle lens

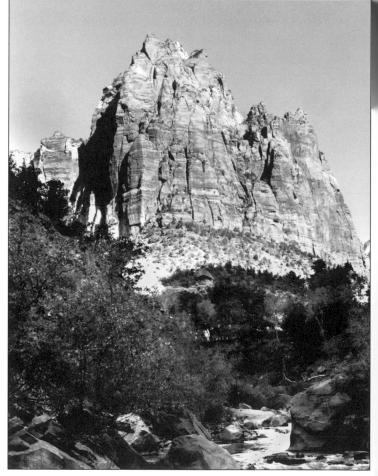

Normal lens

LENS SURFACE

Check for nicks and scratches on the lens surface. Damage to the surfaces of the lens (both the front and rear) can seriously reduce the quality of your images.

CHECK THE WARRANTY

Depending on the dealer, used lenses may or may not have warranties. Typically, the aperture mechanism is not covered.

Cost

Three factors have the greatest impact on the cost of the lens: focal length, quality, and the manufacturer. Ultrawide-angle (or fisheye) lenses or extreme telephoto lenses impose enormous design and manufacturing challenges. For this reason, they are more expensive than normal lenses.

Very fast lenses, with aperture settings of f/1.2 to f/2.0, are typically expensive. Fortunately, you would rarely use such a lens for landscape photography. Therefore, purchase a lens with a maximum aperture setting in the range of f/4.0 to f/8.0.

"Three factors have the greatest impact on the cost of the lens ..."

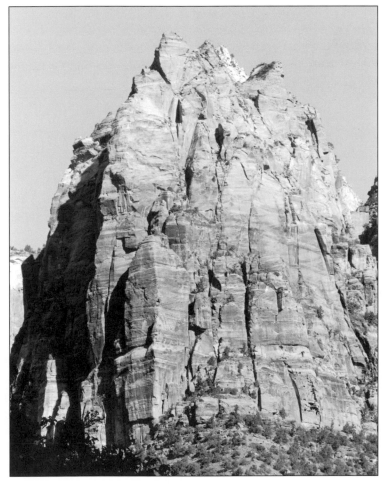

Telephoto lens

A wide-angle lens (far left photograph) includes more of the scene than the other two focal lengths. It exaggerates the effect of depth by including very near foreground objects and by diminishing the size of background objects. In addition, a wide-angle lens increases linear perspective by causing distant parallel lines to converge more noticeably. This exaggeration of perspective also increases the feeling of depth. For these reasons, the wide-angle lens remains a popular choice for most landscape photographers.

The normal lens (center photograph) portrays about the same perspective as does a single human eye.

Finally, a telephoto lens (photograph on this page) reduces the effect of depth by not including nearby foreground objects and by exaggerating the size of background objects. In addition, a telephoto lens reduces linear perspective by preventing distant parallel lines from converging as noticeably as they do with a wide-angle lens. The telephoto lens is the ideal choice in landscapes when the photographer wants to reduce the depth of the scene by compressing the space between the foreground and the background.

Purchasing a high-quality lens will allow you the potential to create the finest landscape photographs. Whether the lenses are new or used, consider buying from the top lens manufacturers.

Perspective

Every two-dimensional photograph is a representation of a three-dimensional scene. Perspective is the relative size, shape, distance, and position of objects in a 3D world when transformed onto a 2D surface. Perspective increases our perception of the original scene's depth.

For example, railroad tracks seem to converge in the distance, even though they actually remain parallel. When photographed from a sharp angle, circles appear elliptical, and rectangles or squares appear trapezoidal.

Technically, only three types of adjustments affect perspective: moving the camera closer or farther from the subject, moving left or right, or adjusting the lens plane or film plane on large-format cameras.

Visually, however, linear perspective, as well as its affect on exaggerating depth, is a combination of several factors. Perhaps the most important factors contributing to a viewer's perception of depth are camera position, changing the distance between objects, how the final print is cropped, and focal length. Generally, a wide-angle lens increases the apparent effects of perspective, whereas a telephoto lens decreases these effects.

Section 1.3
ACCESSORIES
Filters

Filters are an important addition to a landscape photographer's arsenal. Used with black and white film, they help to strengthen contrast. Specifically, they help to darken the sky, accentuate the clouds, and lighten foliage.

To save money, purchase filters to fit the largest diameter lens you own. You can then buy step-down adapter rings to fit your other lenses. The table "Recommended Landscape Photography Systems" on page 9 lists recommended filters. Section 4.2 discusses the use of these filters in the field.

Film

One of the major goals in landscape photography is to obtain the sharpest images with the smallest grain size. To achieve this goal, use slow films, usually ASA 25-200. These films produce the smallest grain and highest resolution but require longer exposure times. Because you will be using a tripod for landscape photography, long exposures are usually not a problem.

Grain and ASA

The faster the film's sensitivity to light, the more apparent the grain. That is, as the ASA numbers increase, so does the film's grain size.

Light Meters

Light meters (also called exposure meters) are classified into two types according to the way they measure light:

INCIDENT LIGHT METERS

Incident light meters measure the light falling directly on the subject. The meter is pointed directly at the light source. Incident light meters are generally used in controlled environments where the light intensity and direction can be altered, such as photography studios or movie sets.

REFLECTED LIGHT METERS

Reflected light meters, on the other hand, measure the light bouncing off the subject. This type of meter is ideal for landscape photography.

Spot Meters
A 1° spot reflected light meter is the most effective way to measure the various contrast levels in a landscape.

Reflected light meters may be further classified by their angle of incidence, that is, how much of the scene the meter "sees" and measures. In order to use the Zone System of exposure (see Section 4.3), you need to measure the levels of gray in multiple, small areas of the scene. The most effective type of meter to use for landscape photography is called a spot meter. This meter's angle of incidence is very small – about 1°.

Small format and medium format cameras usually have meters built-in. These meters are often very sophisticated and can perform not only spot metering but also wide-angle and combination metering. Large-format cameras, however, do not have built-in meters. Therefore, purchasing a handheld 1° spot meter is very important in order to use the Zone System and produce excellent photographs.

Tripod

In addition to the camera and lens system, the most important piece of equipment you will own is a tripod. In order to achieve landscape photographs having large depths of field, shutter speeds are often quite long. Any movement of the camera during these long exposures will result in a blurred photograph. Therefore, a sturdy tripod is almost a necessity.

Tripods are constructed of various materials, including wood, metal, aluminum, and modern composites. You will often be carrying your equipment for long distances, so size and weight are important considerations. Aluminum tripods are lightweight, very sturdy, and relatively inexpensive.

The telescoping tripod legs should extend to different angles relative to the ground. For photographing in tight places, difficult camera placements, or moving the camera low to the ground, this feature is essential for landscape photography.

"... a sturdy tripod is almost a necessity."

"... consider purchasing a tripod that can be used with the next larger format size."

Tripods may or may not include a swivel head. If not, you can purchase one separately. The two most common types of heads are a ball head and a pan/tilt head. Both of these allow almost unlimited camera movements, including swivels and tilts. The most versatile head for landscape photographers (especially for large format) is the pan/tilt head. These have separate handles for each of the rotational and tilt movements to achieve very precise control over camera position.

Finally, consider purchasing a tripod that can be used with the next larger format size. For example, if you are planning to use a 35mm camera, consider buying a slightly larger, sturdier tripod that is adequate for a medium-format system. This larger size not only will provide you with very flexible and sturdy support but will also allow you to move up to a medium-format camera in the future without the need to purchase another tripod.

Backpack

Because you will often walk long distances to photograph landscapes, carrying your equipment in a backpack is generally preferable to using a camera bag for several important reasons.

First, the weight is evenly distributed on both your shoulders and back. Purchase a backpack with thickly padded straps that are well constructed. Second, using a backpack leaves your arms and hands free with unrestricted movement. A shoulder bag, on the other hand, can often be cumbersome while hiking or climbing.

Check that the backpack is large enough to hold not only your camera body and several lenses, but also film, filters, a light meter, food, water, and other items. Some backpacks have external straps to carry your tripod. Other features include external pockets, removable interior dividers, and very strong, water-resistant materials and construction.

Shutter Cable Release

Although a cable release is very inexpensive, it is an imperative addition to your equipment list. Most of the time, you will be using slower speed film with small apertures in order to capture the scene with the sharpest focus and the largest possible depth of field. This combination requires long exposure times. The camera is extremely sensitive to movement during exposure, especially when you click the shutter open. To avoid the possibility of camera movement, always use a cable release. Lengths of cable releases range from a few inches to two feet. In order for you to walk around the camera, adjust the lens, and stand away from the tripod, purchase a cable twelve inches or longer.

Changing Bag and Tent

For small-format and medium-format photographers, a useful field item is a small, inexpensive, black film-changing bag. If

you are miles away from home and your film jams in the camera, a changing bag will allow you to open the back of the camera to either repair the problem or to remove the film safely.

For large-format photographers, a changing tent is preferable to a changing bag. A tent allows you to place your hands into sleeves and insert sheets of film into film holders. You can either load enough film holders for your entire day's session, or you can take the tent into the field. Just as a camping tent, these changing tents collapse and fit into a small bag.

For landscape photographers, a changing bag can be useful for another reason. In those situations, when the light or weather changes dramatically, you can use a changing bag to remove a partially exposed roll of film and insert another type of film.

Tool Kit

Sometimes when you are in the field, you will need to make very minor repairs or adjustments to your equipment. A small tool kit consisting of a jeweler's screwdriver, small needle-nose pliers, and a roll of electrical tape would be adequate. The cost and weight of these items is negligible, but they could save your photo session in the event of broken equipment.

Batteries

Most small-format and medium-format cameras, as well as hand-held exposure meters, use batteries. Backup batteries should be a standard part of your camera accessories that you always have in your backpack.

Large-Format Camera Accessories

Three other accessories are necessary if you have a large-format camera:

FILM HOLDERS

The standard holder accepts two sheets of film, one on each side. As a landscape photographer, you should probably carry at least six loaded holders (12 exposures) for extended trips. Holders are available in either plastic or metal. The cost, weight, strength, and durability is about the same for both types.

DARK CLOTH OR HOOD

The image in a large-format view camera is projected onto a ground-glass plate. In order to eliminate extraneous light and to help focus the image, you need to drape the cloth over the back of the camera. However, during windy conditions, the free-hanging dark cloth is often unmanageable. Easier to control in windy conditions is a dark hood. This hood fits

"... they could save your photo session in the event of broken equipment."

securely and completely around the back of the camera and cannot blow around like a dark cloth.

FOCUSING LOUPE

> "... the loupe allows you to focus very precisely."

Also called a focusing magnifier, the loupe allows you to focus very precisely. The loupe is placed directly on the ground glass, and the bellows are moved until the image is in sharp focus. For the finest focus, purchase a loupe with a magnification of at least 4x to 8x. The quality, size, weights, and costs of loupes vary widely. Because extremely sharp focus is critical to achieving an excellent landscape photograph, a high-quality loupe is a necessity. The loupe can be used not only for focusing but also for critical inspection of your negatives on a light box.

Section Two
LANDSCAPE PHOTOGRAPHY AS AN ART

As a first step to creating fine art, precisely defining it would seem imperative. However, such a clear definition is difficult or impossible. The subjective nature of art requires a more indirect explanation, one that stems from and changes among personalities, experiences, generations, and cultures. As photography assumes a more dominant role in the wider realm of fine art, exploring b&w landscape photography within this realm is both timely and necessary.

Even the definition of what constitutes a landscape is complex. As humans expand territorially, their transformation of the landscape becomes wider and more permanent. Over time, these synthetic landscapes often become as integral to the earth as any natural landscape. This expansion offers landscape photographers an almost unlimited selection of subjects.

Successfully transferring the landscape from the lens to the final print requires personal creativity equally coupled with proven photographic techniques. In the final analysis, art is not so much what the subject is or what techniques the photographer uses, but what the artist and viewer feel.

> "Even the definition of what constitutes a landscape is complex."

Section 2.1
WHAT IS ART?

Art defies any clear and concrete definition. However, most artists agree that art is a combination of creativity and technique. The interpretation of any creative endeavor varies throughout time and among cultures. Works that are regarded as merely experimental or faddish today may be deemed as highly artistic in the future. What is beautiful, dramatic, or meaningful for one person or culture may not be for another. The social and creative changes that a work inspires among one or more cultures may also help to differentiate art from non-art. No matter how many criteria and measurements one assigns to a creative achievement, the definition of art remains elusive and highly subjective.

Test of Time

A common measure of a work's artistic value is how well it endures popular and academic scrutiny over the years. Applying the test of time may be a valid method for creations of the past, but it fails for contemporary ones. Although a work may be popular today, it may not carry the same importance in the future.

An alternative method of the endurance test is the evaluation of any creation during your own lifetime. For example, does a particular photograph that initially impressed you continue to affect you as the months or years go by? Does that image elicit new or renewed personal, social, or artistic significance every time you see it? The ability of an image to engage the viewer's interest and to reveal new meaning long after the work has become familiar is the ultimate wish of any photographer – and one that may help to define fine-art photography.

Subjectivity of Art

Art is subjective because it embraces not only technique but also creativity and imagination. The artist brings to the image the

The smooth water, the distant mist, the isolated viewpoint, and the vertical orientation work together to form a mood for the viewer. The ability to direct and control, to some degree, the viewer's response is an important facet of art.

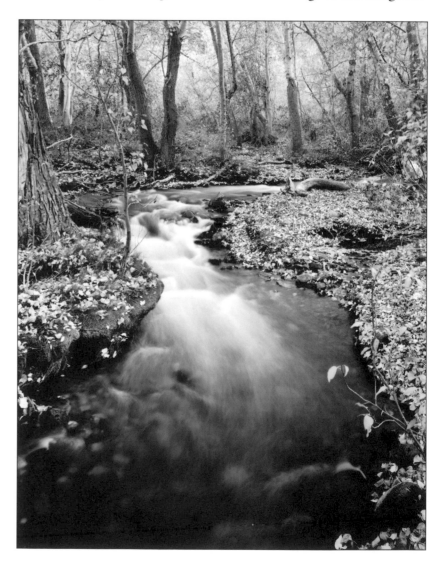

creativity of mood and feeling. The viewer's response to art is also subjective. A photograph's impact and meaning is dependent on the viewer's age, culture, experience, memory, and personality.

Some elements of an image are clearly objective, tangible, and measurable – the location and date of the image, the subject matter (trees, water, clouds, sand), the weather conditions, the direction and intensity of the light, and the overall contrast range. The underlying mood or feeling of the image, however, is more elusive. Because this mood is subjective and intangible, different people will respond differently to the same image. What appeals to one may not appeal to another. This undefinable quality is the dynamic life of all art forms.

Artistic Control

Even though the same image can elicit varying responses, most viewers react somewhat consistently to photographic elements such as lighting contrasts, natural subject matter, and typical weather conditions. This consistency allows the landscape photographer a certain degree of artistic control over the viewer's response. Almost without exception, creative endeavors evoke certain passions within the artist. The goal of most artists is somehow to convey those same feelings to most viewers consistently across time and cultural barriers. Using deliberate compositional, field, and darkroom techniques, the photographer can, to some degree, control the viewer's reactions to a particular image. This control is yet another measure not only of the artist's skill and creativity but also of the image's strength as a work of art.

What Makes a Good Landscape Photograph?

Perhaps the most important controlling factor in landscape photography is composition. Strong images usually result by using a combination of compositional elements: physical, technical, and design. Physical elements consist of shapes, lines, textures, patterns, and the interplay among them. Technical considerations such as camera placement, shutter speed, aperture setting, lens selection, focus, lighting, and contrast are equally important tools for achieving strong compositions. Design elements are more subjective, including visualization, weight, balance, simplicity, dynamics, mood, and impact.

In addition to compositional elements, great images are the result of darkroom skill, experience, confidence, patience, study, criticism, and a bit of luck. The more images you take, the better photographer you will become. Technical expertise is not the only knowledge gained through experience. Your personal photographic voice will also improve as you become more confident.

One overlooked skill is the ability to develop a critical eye. Offering creative, constructive criticism of other artists' works is both challenging and beneficial to your own growth. Even more

"... creative endeavors evoke certain passions within the artist."

important, however, is an artistic and analytical review of your own work. Although learning to be objective about your own images takes time and the willingness to forego some of your pride, it is worth the effort. Critical analysis of your own photographs and those of others will quicken your artistic and technical development.

Time plays an important role in landscape photography. Weather, lighting, and seasons change. Natural erosion and environmental shifts occur over the years. Unnatural pollution and destructive effects of humans permanently alter the face of the landscape. Understanding and using these changes artistically keeps your landscape images dramatic and socially meaningful.

Unintentional & Intentional Manipulations

Even if our photographic approach is more documentary than artistic, unintentional manipulations make it difficult to portray the landscape as it exists. The fine-art photographer cannot rely on unintentional manipulations alone but must explore intentional manipulations as well.

Unintentional Manipulations

- Focal length
- Depth of field
- Color to b&w
- Depth (3D to 2D)
- "Unlimited" view to framed view
- "Unlimited" tonal range to limited tonal range
- All five senses to one sense (sight)
- Actual scale to reduced scale

Intentional Manipulations

- Filters, Zone System, darkroom techniques, changes in contrast and tonal range
- Intentional blurring
- Intentional removal or addition of scenic elements (or collages)
- Add color through toning
- Exaggeration of grain for effect

Section 2.2
MANIPULATING THE LANDSCAPE
The Expressive Power of Change

Painters can easily alter any aspect of the landscape on the canvas. By changing the actual scene's weather or lighting conditions, they can convey a different mood. Painters can shift hues and contrast to best fit their previsualized image of the scene. Objects can switch places, become larger or smaller, or disappear altogether. The final creation should be exactly as it was in the painter's mind – nothing less, nothing more – even though this creation may not at all resemble the original scene.

Photographers, on the other hand, cannot alter these aspects as easily as a painter with a completely blank canvas. They can, however, significantly control and even modify the original scene's contrast, perspective, and apparent distance among objects. Using sophisticated compositional, field, and darkroom techniques, photographers can portray the landscape in a way that viewers have never seen before.

More important than the freedom of the painter to change the landscape is the viewer's own freedom of interpretation. Viewers expect, in some ways, a landscape on canvas to be a non-literal representation of the original scene. As such, even significant departures from reality in terms of lighting, color, and perspective seem reasonable and acceptable.

In stark contrast, most viewers expect a large degree of reality in a photograph. After all, a camera supposedly records the original scene without alteration. Even a small change from the viewer's preconceived ideas of reality in a photograph will be immediately noticeable, even if acceptable. Altering the original scene's contrast, perspective, or focus to ones that we could never see with the naked eye will be far more noticeable in a photograph than in a similar painting because of the viewer's notion about each medium and its intended portrayal of reality.

This difference between photography and all other art forms gives photography an artistic edge in many respects. Even the slightest deviation from a "normal" scene will scream for attention in a photograph. The same change in a painting, work of fiction, or cartoon may go unnoticed altogether. Mood and drama are easier to exaggerate because the viewer, through experience and perceptions of the real world, expects a photograph to represent reality quite literally. The photographer, then, has enormous latitude for expressiveness through the manipulation of the original scene. Perhaps the biggest departure from reality is the depiction of the landscape in black and white.

Why Black and White?

The real world is a color world. Landscape images in b&w are more fictional than those in color, so the b&w photographer inherits an enormous degree of latitude in further manipulating reality. Deciding between color or b&w should stem from an artist's intention and creative preference.

Certain subjects and photographic requirements demand color film. If color is so important to the scene that it is the primary or distinguishing element of the photograph, then color is the obvious choice. For absolute realism and accuracy, most scientific, documentary, educational, geological, or advertising landscapes excel in color. In these cases, technically perfect and visually accurate representations of the actual landscape are often imperative. We are born into a world of color. We live in color. We see, interpret, and dream in color. From the standpoint of aesthetics and realism, many photographers prefer to use color in their fine-art representations of the landscape.

Seeing the world in black and white is not better or worse. It is a variation in the same way that prose differs from poetry, or fiction from nonfiction. Photographers who prefer to represent the landscape in b&w do so because of artistic intent and preference. Because the removal of color from a landscape immediately transforms the scene from one of reality to one of fiction, the b&w photographer can experiment more freely with abstraction and symbolism.

Some of the world's best landscape photographers use color film exclusively. Others use only b&w film. Still others use both equally, depending on the subject and mood they want to capture on film. Moving from a strictly nonfictional style of writing to a much freer fictional world affords the author a fresh, unlimited wealth of stories and text. In the same way, as soon as a photographer crosses the threshold from color to b&w, new approaches with unlimited creative potential transform everyday landscapes into new, exciting worlds.

"...the b&w photographer can experiment more freely with abstraction and symbolism."

Section 2.3
TYPES OF LANDSCAPES

A traditional definition of landscape is the view of nature without any trace of human impact. Another definition includes our effect on nature – our contributions as well as our destruction. What gives the land its particular character is the positive and negative effects of mankind.

The intensity of emotion that is possible with expansive vistas is also possible on an intimate scale. Sometimes, close-ups are capable of expressing the magnitude and the passion of landscapes equally as well.

As progress encroaches on the natural environment, finding a pristine landscape, void of human intervention, becomes harder and harder. The use of handmade or manufactured objects adds interest visually and thematically to the scene. However, these elements should be secondary and not detract from the landscape. The landscape is still the key focal point.

Architectural structures enhance or detract from the landscape, depending on their compositional dominance and weight within the scene. Including abandoned structures such as ruins, ghost towns, or deserted buildings in your landscape images invokes a different feeling than using occupied dwellings such as skyscrapers, housing tracts, or cityscapes. In a different but equally powerful way, manufactured objects such as a sea of tract housing or a cityscape, are increasingly replacing our natural landscape. For some photographers, such synthetic landscapes express a socially relevant and artistically dramatic statement of human intervention in nature.

In an abstract view of landscape, the scene's dimension, scale, and subject are difficult to define. The viewer's first reaction is usually, "What is it?" The object or scene appears to be something other than the actual object. The photographer's intention is usually metaphorical and graphical rather than literal and realistic.

Photographers should neither shy away from traditional subjects nor be afraid of exploring the non-traditional themes that also define landscapes. Your primary goal as a landscape artist should be to photograph the land through your own eyes according to your unique point of view and personal vision.

Section 2.4
CREATIVITY AND TECHNIQUE

Nature and reality are the basis of art, but art should not mimic nature precisely. The artist uses personal experience to create a subjective interpretation of nature. This subjective contribution on the part of the photographer defines creativity and differentiates a simple image from a work of art. The photographer can technically mimic the works of predecessors in a nice display of

Landscape Elements

Regardless of your personal definition of landscape, the primary elements that define the landscape are:

Primary Elements	Sky, water, land
Secondary Elements	Trees, plants, rocks clouds
Effects of Nature	Pattern, texture, erosion, pollution
Effects of Mankind	Architecture & other man-made objects

Differences Between Creativity & Technique

The sources of creativity are different from those that comprise technique. Art is a balance between the freedom of creativity and the control of technique.

Creativity

- Personal experience
- Individuality
- Inspiration
- Freedom
- Feeling
- Emotion

Technique

- Learned skills
- Conformity
- Simplification
- Control
- Organization
- Information

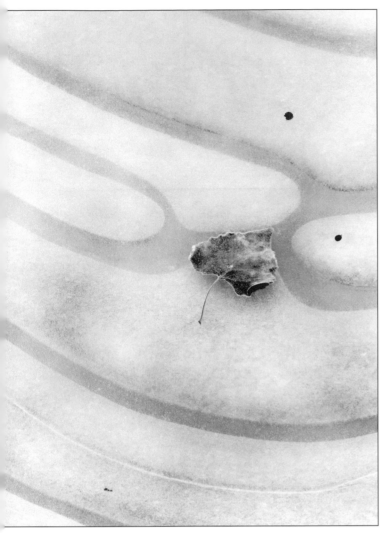

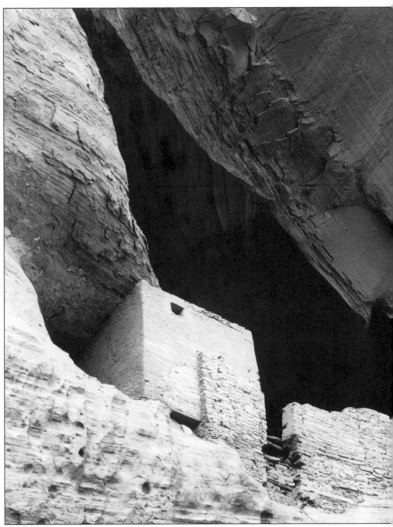

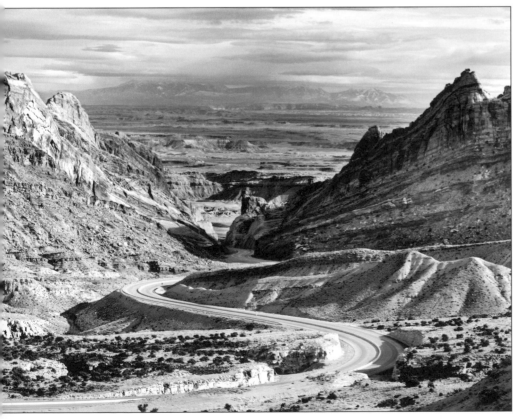

Top Left: *Close-ups are an effective way to express an intimate detailed view of the landscape. The single leaf not only adds a strong focal point but also a reference to the dimension of the ice swirls. Also note how the additional two small leaves create an imaginary triangle, adding visual movement.*

Top Right: *This cliff dwelling, built from the rock itself, becomes an integral, natural part of the rock. The dark, triangular crevice effectively leads the eye to the ruin and offers a tonal contrast to the rest of the scene.*

Bottom: *The highway appears to be a natural extension of the landscape. Its smooth s-shape effectively contrasts with the craggy texture of the mountains.*

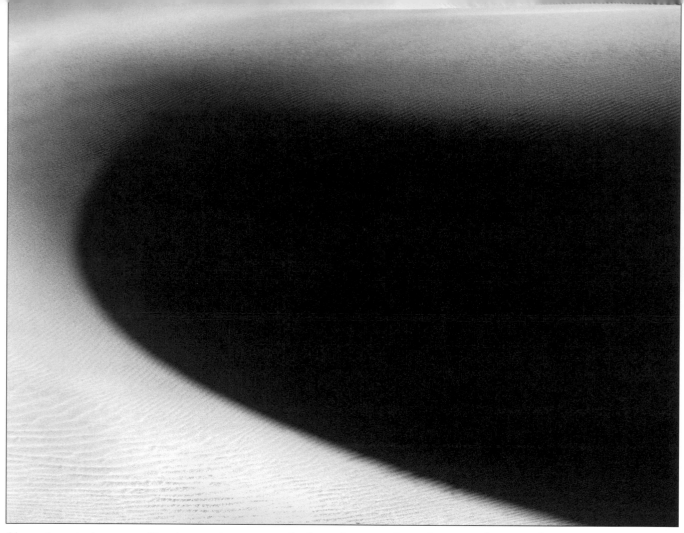

Many elements in nature offer abstract views. Without other recognizable elements, the viewer is left to wonder what it is, where it is, and how large it is. Even with abstract landscapes, strong compositional elements and design are critical to achieving a dramatic image.

craft, but the creative photographer's individual voice is what makes an image artistic.

Every landscape photograph is an equal combination of the original scene and the subjectivity you add as an artist. As a photographer, you are like a novelist who creates and tells a unique and personal story. Like the landscape, the words already exist. Using years of training, experience, and opinion, the novelist shapes these words and gives them a meaning. Similarly, the photographer unites technique with creativity to reshape the landscape into a unique, very personal representation of the world.

The overemphasis of technique in classes and books is common because technique is easier to teach than creativity. Dependence on technical solutions as substitutes for creative decisions is an easy habit for photographers to develop. Just as a magician pulls a rabbit from a hat, the photographer can become complacent with over-emphasizing technical solutions while under-emphasizing creative decisions. The development of artistic skill is one that takes time and experience. However, a solid base of technique is necessary in order to transfer artistic vision onto film. For this reason, most photographers agree that both technique and creativity are equally important in the creation of art. The following sections present the compositional and technical skills you will use to bring your artistic vision to life.

Section Three
COMPOSITION TECHNIQUES

Creation and Control

Composition is the organization or controlled arrangement of different elements to achieve a unified structure. A composition is not a random arrangement of the elements in a scene. In a fine-art landscape, the photographer transforms haphazard elements into a controlled, ordered work. The photographer, as with any other type of artist, carefully arranges the scene by determining which elements to include and where in the frame to place them. The photographer organizes the lines, shapes, textures, patterns, focus, highlights and shadows, and viewpoint. The photographer directs what and how the viewer sees. If a scene is unorganized, the viewer cannot see – or feel – the photographer's theme or point of view. A composition is unified because the various elements in the scene work together to form a single concept.

Without careful composition, the mood or feeling, the balance, the impact or drama, and the control over what the viewer sees would be random. If you simply "point and shoot" the camera, you have simply recorded the scene as it is. You have created nothing, and usually the photograph will say nothing to the viewer. The enjoyment of fine-art landscape photography lies in your ability and freedom to create a scene and to control the placement, focus, lighting, and mood of the elements.

How the Eye Sees

Understanding how the viewer's eye and mind sees and organizes a photograph helps you to compose your scenes for the strongest clarity and impact.

First, the human eye has an extremely narrow angle of sharp vision – only about three radial degrees. To illustrate this, hold any 8x10 photograph or newspaper about a foot in front of you. Now focus on any area. Notice how even nearby areas are out of focus. Your peripheral vision can still recognize nearby words or shapes, but you cannot really bring them into sharp focus unless

> "... the photographer transforms haphazard elements into a controlled, ordered work."

"... the photographer controls to an amazing degree what the viewer focuses on ..."

you look directly at them. Because of this narrow range of focus, the eye scans a photograph in small segments. However, the eyes do not scan strictly left to right, top to bottom. Instead, the eyes quickly dart in a seemingly arbitrary fashion around the photograph while the mind attempts to define, categorize, organize, and finally interpret the scene. These eye movements, however, are not entirely random, but instead greatly controlled by the composition itself. As a general rule, the eyes first move toward areas of strong contrast, shapes, and textures. Also, the eyes always follow strong lines from their beginnings to ends.

The eye does not scan every three-degree area for precise, focused detail. Most fine details remain somewhat fuzzy to the viewer. The mind fills in the remaining, unfocused details and creates a single, organized scene. For this reason, careful composition is imperative as a means to insure that viewers see what you want them to see.

Therefore, the photographer (as an artist) controls to an amazing degree what the viewer focuses on and in what order. The compositional techniques in the following chapters can improve your ability to control the scene and the viewer's approach to your artistic landscapes.

Compositional Elements

The most important elements in composition are the visual components, viewpoint, lighting, tonality, contrast, focus, and overall design. The following chapters discuss each of these topics. This collection of compositional ideas and techniques should function as a springboard for your artistic and technical development. These are guidelines only as you begin to search for your own, unique compositional style.

Ultimately, history determines what is good composition and what is not. Photographers who have gone beyond traditional techniques and design have often expanded current opinion of what is good. Studying the techniques used by great photographers, both past and present, will give you a starting point on which to build. These principles should help to increase your perception, photographic vision, awareness, and skill in creative composition. However, these proven techniques should never limit your creative ability. Instead, they should inspire you to experiment, evolve, and create your own personal view of the landscape.

Section 3.1

VISUAL ELEMENTS: SHAPES

Every landscape photograph contains one or more shapes. Some shapes are literal, such as the triangular shape of a mountain peak. Other shapes are implied, such as the placement of

three stones which form a triangle. Whether literal or implied, shapes are one of the best compositional methods for achieving strong design in your landscapes.

Shape refers to an object's two-dimensional outline – circles, triangles, squares, rectangles, or irregular forms. A shape serves two primary functions in photographs. First, because it is so familiar, it creates a sense of stability, strength, and restfulness. Second, even as the eyes dart around the photograph gathering detail, a strong shape demands the viewer's attention.

Multiple shapes can suggest complete rest or hectic movement. They can make the eyes jump back and forth among them, or lead the eyes to the main subject. They can relax, agitate, or confuse the viewer. Ultimately, shapes have the power to control the scene and the viewer's reaction to that scene. Understanding how shapes work for you – or against you – will help you to create more powerful landscape compositions.

Completion of Shapes

If the object in your landscape is complete, that is, you photograph it in its entirety, the viewer has very little work to do. Such a complete subject allows the mind to rest, to think, to concentrate on detail rather than on form. When that object is cut off by the edge of your frame or by a closer object, the viewer automatically and unconsciously completes the shape.

Completion creates a more dynamic, open photograph. Incomplete elements, such as a partial mountain range, half of a tree, or a portion of a rock in the foreground, create a much larger virtual scene. These objects help to remove the confines of the photograph's borders. The viewer becomes an active participant in recreating the entire 180° scene.

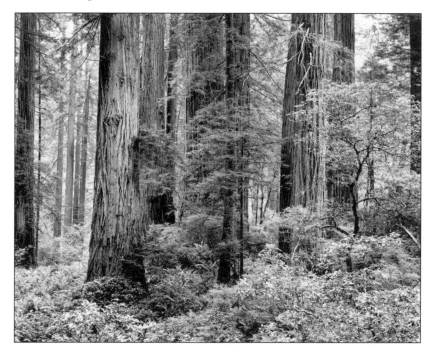

The top border cuts off the trees, inviting the viewer to complete the shapes. This completion forces the viewer to be a part of the original scene.

31

Factors that determine whether a shape is dominant, supporting, or background

- Size of object
- Location of object within frame
- Lighting
- Contrast with other subjects
- Detail
- Texture
- Uniqueness
- Completion of object

As our mind attempts to complete the shapes, the eyes first focus on the complete shape in a scene. Then, the mind tries to recognize and complete all the broken shapes. The viewer often interprets the complete object as the main subject, and any incomplete shapes as secondary or supportive elements.

There are advantages and disadvantages in photographing broken or fragmented shapes. Fragments are more abstract and dynamic. They challenge the viewer and open the door to multiple interpretations. Conversely, photographing complete shapes on their own simplifies the compositional process by eliminating the need for secondary elements. You are telling the viewers what they are supposed to see, not what they think they are supposed to see. But, complete shapes can also complicate the compositional process by not giving the viewer a frame of reference to determine an objects depth and size. The complete shape must also be powerful enough to say what you want it to say to the majority of your viewers.

Dominant, Supporting, and Background Shapes

Shapes that are dominant, often called spots, are visually more prominent than other shapes in the photograph. Generally, complete shapes that contrast highly with the background dominate the scene. Other shapes, if related to the theme of the photograph, are supporting. Extraneous shapes in the background help to create character, texture, and depth, but do not compete visually with the dominant shapes.

Circles

Circular objects, such as rocks or pools of water, portray serenity and completion. They hold the eye still and invite the viewer to look more closely for detail. Even when only a part of a circle is visible, the mind easily completes the shape. The circle acts as a strong visual weight.

A circle's shape is foreign to the rectangular frame of the photograph. This difference gives the circular shape very strong visual dynamics and importance. While a circular shape, in itself, does not possess rhythm or suggest movement, its juxtaposition in a rectangular frame does, particularly when part of the circle is incomplete. It becomes, in a sense, a round peg in a square hole and demands the mind's attention.

Squares

Like a circle, a square is somewhat foreign to most photographic formats. Its perfectly symmetrical shape suggests visual rest. Also like the circle, a square acts as an anchor for the photograph, giving a feeling of weight and permanence. However, because of their simplicity and symmetry, both the circle and the square can be static and monotonous shapes. Often adding a con-

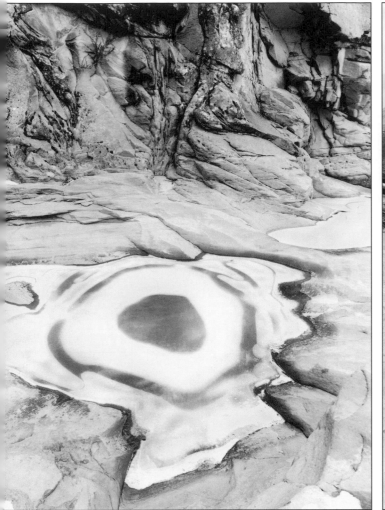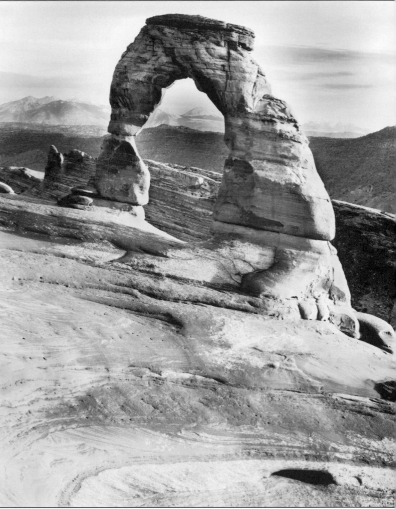

trasting shape, texture, or tonality to these simple shapes strengthens the scene by introducing some visual interest or movement.

Rectangles

Certainly, the most prevalent shape of our modern societies (photographs, paintings, billboards, books, letters, houses, cars, even the human form) is rectangular. In nature, mountain ranges, trees, waterfalls, the horizon, and fences all suggest rectangles. This shape is so common and familiar in both manufactured and natural objects that most viewers rarely notice it. Instead, they usually concentrate on the details within the rectangular frame. Shapes other than rectangular, however, are more apparent and command more attention. A viewer is likely to notice the shape first and then the details within the shape.

Triangles

The most dynamic compositional shape is the triangle. Like the circle, its shape is foreign to the rectangular borders of the photograph. In addition, at least one of its three sides creates a diagonal line, suggesting movement and unrest.

Left: The circular designs in this ice patch immediately become the focal point of this photograph. Its strong dominance is due to its simple shape and its strong tonal and textural contrast with the surrounding rock. Although the lines in the rock and even the rock itself suggest random shapes, they are only supporting in character. The eye roams around the scene but continues to return to the dominant shape.

Right: The circular shape of this archway immediately becomes the dominant focal point. Even though the distant mountains are triangular shapes, they simply add character and location reference to the scene. The incomplete circular patterns in the foreground support the shape and character of the archway. In addition, they add movement to the scene by forcing the viewer to complete the circles. As an experiment, cover up the lower third of this photograph. You will see that the scene becomes static.

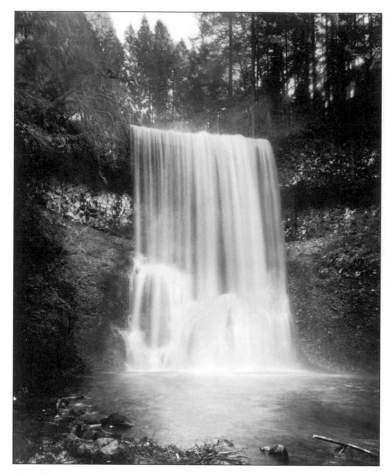

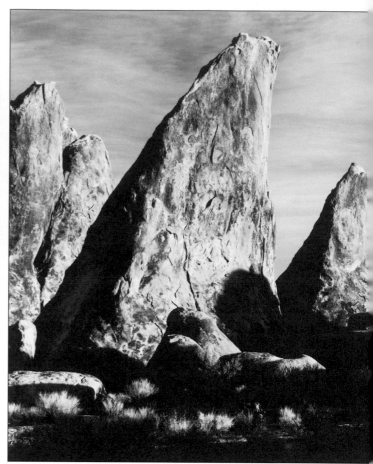

Top Left: *Unlike the static nature of squares, rectangles often suggest movement and enhance height or depth. In addition to offering the strength of a square, the vertical waterfall increases the feeling of height. The vertical lines throughout the waterfall enhance the direction and height of the trees, which serve as a supporting background.*

Top Right: *Strong triangular shapes are often easy to find in nature. Because of their diagonal lines, they add visual movement and interest to landscapes.*

Bottom: *The square-shaped rock in the background suggests restfulness and quiet. The curved swirls in the foreground create movement which contrasts effectively with the static feeling of the square.*

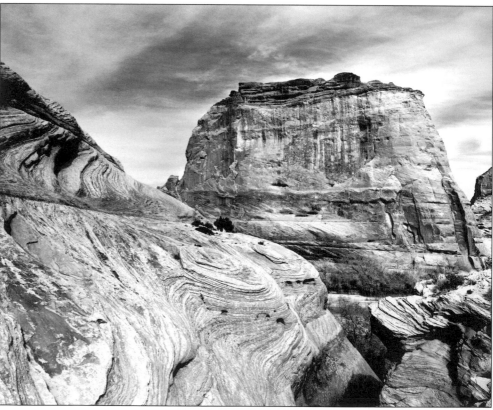

A triangular shape generally suggests movement in the direction of one or more of its vertices. Which vertex indicates this movement depends on the placement of the triangle and the actual subject. Usually, if one side of the triangle is parallel to one side of the photograph's borders, the vertex opposite that side indicates the overall direction, or flow, of the photograph. The most common example of this orientation is a mountain peak. The eyes are drawn from the sides of the mountain up to the peak, then up into the sky. Strong, horizontal clouds keep the viewer's eyes from leaving the frame entirely.

Irregular Forms

The detailed outlines of many shapes found in landscapes are irregular. The outline of tree branches seems highly irregular. However, when the photograph is viewed as a whole, those irregular branches form a nearly circular shape, and the separate branches create the circle's rich texture. Learn to see the overall shapes of the elements in your scene. Usually, these shapes will be one of the fundamental shapes described above. If the shape is completely irregular, it may create a very dynamic subject.

Distracting Spots

The ability of spots to draw and hold the viewer's attention and focus can work for or against you. If the main subject in your photograph (for example, a single mountain peak or a single leaf) acts as a dominant shape, your photograph will be strengthened. You will hold the viewer's attention on your main subject. However, if another element in the scene acts as a spot, then the viewer will concentrate on that shape, not on your main subject.

Distracting spots can be either thematic or extraneous. A thematic spot is an integral part of the scene and relates to the overall theme, mood, and character of the main subject. For

Below Left: *Most mountain peaks such as this suggest upward movement. An effective technique is to stop the viewer's eye from leaving the frame by stopping the direction of flow. In this example, the strong, horizontal clouds prevent the eyes from flowing up the triangle's vertex and out of the frame. Note how the smaller triangular and circular rocks in the foreground add support and contrast to the large mountain.*

Below Right: *The shapes of these individual branches and limbs are highly irregular. However, as a group they support a single, incomplete circle. The branches and leaves simply function as supporting texture.*

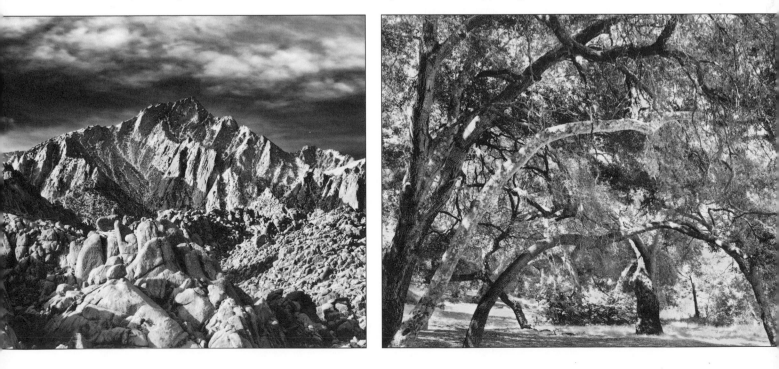

Improving Composition Through Viewpoint

Often just moving the camera slightly to the left, right, up, or down will give you a much more powerful composition by removing distractions.

Compare the photograph of the arch on page 37 with the distracting rock on the left side with the improved version on page 33. Note how the improved version not only eliminates the distracting rock but also includes the circular patterns in the foreground. These circular shapes greatly enhance the circular shape of the arch and emphasize the slope of the mountains.

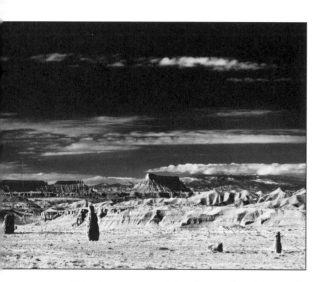

This is a compositionally weak photograph. Several small dark rocks invade the scene as distracting, confusing spots. These shapes detract from the overall strength of the scene.

example, a rock in the foreground of a mountainscape is consistent with the character of the scene. That rock becomes distracting, however, when it contrasts so sharply with the background that it steals attention away from the main subject.

If you have one or more of these thematic yet distracting spots in the scene, their contrast with the background can often be reduced. In the field, sometimes waiting for the lighting to change or shadows to shift will help to reduce its prominence. In the darkroom, either burning or dodging the object will help to match its tonality closer to that of the background.

An extraneous spot, on the other hand, is always distracting. This type of object should never be in the photograph in the first place because it does not relate directly to the theme. Worse, it competes in importance with the main subject. Examples include lens flare, contrails of an airplane, a scrap of debris in an otherwise unspoiled landscape, or the tip of a branch hanging into the upper corner of the sky. If possible, eliminate distracting shapes by changing the viewpoint, by using a different lens, or by cropping the photograph in the darkroom.

Multiple Shapes

Whether intentional or unintentional on your part, two or more dominant shapes cause the viewer's eyes to jump back and forth between them. This effect becomes increasingly pronounced the farther away the two spots become. If both these dominant shapes are similar or thematically related, and if they are both part of your main subject, then the added interplay and dynamics may be very effective.

If, on the other hand, only one of these spots is the main subject, then the other spot becomes distracting and obtrusive. Again, the key is simplicity. Make a point – a single point. What shape do you want the viewer to concentrate on? Adjust your viewpoint to achieve a well-defined, thematically-focused composition.

Repetition of shapes can add strength to your photographs, assuming, of course, that the repetition intensifies your subject matter. These repeated objects will be even more interesting if they vary from the main subject in size, tonal range, texture, or orientation. Used in a carefully controlled way, repetition can add strong dynamics to an otherwise static photograph.

Visual Lines and Shapes

When your photograph has three (or more) dominant shapes, the eye will attempt to form an imaginary line or shape through them. These spots can be different shapes, sizes, or even subject matter. The mind's eye organizes multiple shapes into easily recognizable forms by "connecting the dots." This automatic process can work for or against your photograph.

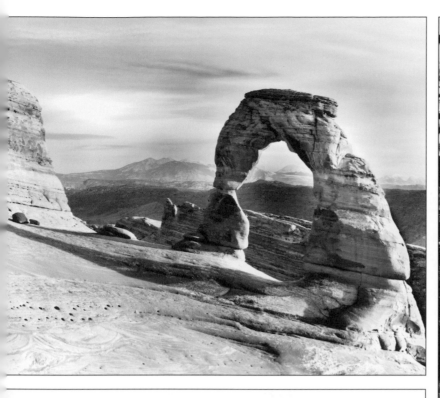

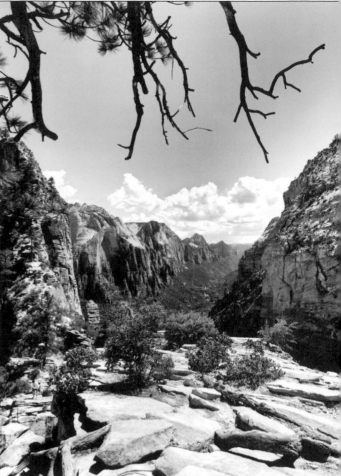

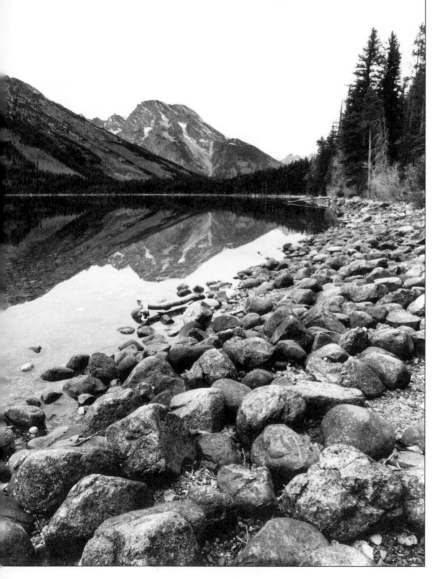

Top Left: *This photograph includes a section of rock on the left-hand portion of the frame. This rock serves no useful compositional purpose here. Instead, it acts as a distracting spot, drawing the viewer's attention away from the main focal point — the arch.*

Top Right: *The overhanging tree branches only distract from the rest of the scene. By using a different camera position or lens, you can eliminate these compositional weaknesses.*

Bottom Left: *This photograph demonstrates several strong compositional elements. The distant center mountain is clearly the dominant shape. The hill on the left and the trees on the right lead the eye down toward the mountain. The hill and its reflection form a strong triangle, leading your eye toward the mountain and its reflection. The bank of the lake forms a circle that leads your eye from the foreground to the base of the mountain. The repeated, circular rocks diminish in size as they fade into the distance, enhancing the feeling of depth. Finally, the foreground rocks, the circular lake, the left hill, and the right trees are all incomplete. These incomplete shapes require the viewer to participate by imagining the scene beyond the borders.*

If the shapes form an imaginary line, the eye will follow it back and forth. This line will give your photograph movement and create cohesion among the objects. The effect of the line intensifies if your subject also shows movement in the direction of the line. Likewise, three or more spots can create an imaginary shape. Three objects not in a straight line, for example, suggest a triangle. Depending on the size, position, and orientation of this imaginary triangle, it may suggest movement in the direction of one of the vertices. If this suggested movement points toward the main focal point or emphasizes the same directional flow of the main subject, it may strengthen the composition.

Also note that any line or shape, imaginary or actual, divides your photograph into even more visual shapes. Depending on the angle of an imaginary line, your photograph may be split into either two rectangles, two triangles, or two trapezoids. This division, if obvious, may or may not be your intention.

The grouping of similar shapes with few interruptions is important if you want to create a feeling of continuous movement. For our eye to complete lines and shapes, they must be in relative proximity to each other, have a similar shape, and make a continuous form. In the photograph below, for example, the clumps of grass are close to one another, all circular, and form an obvious unbroken triangle.

The effects of visual lines and shapes can be very powerful in your landscapes. Use them to help guide the eye from object to object or to form a single dominant shape. Learning to control these imaginary lines and shapes will further strengthen the photograph's composition, organization, and interest.

Although both photographs contain three strong visual spots, the imaginary triangle in each serves a different compositional purpose. In the left image, the three rocks are supporting shapes and help lead the eye from the camera to the distant hills. The triangular shape also serves to balance the visual weight of the hill and sky in the background. In the photograph on the right, the three bushes form a triangular shape that becomes the subject itself. Because the background omits a sky or horizon, our attention remains on the triangular shape. The pseudo-horizon formed by the pond's edge is almost centered across the frame, suggesting a calm, static scene.

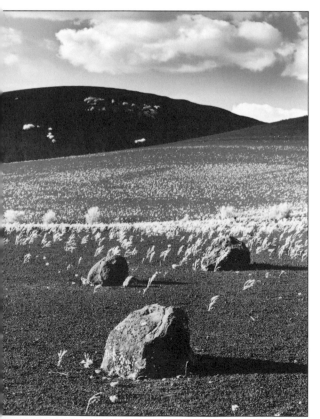

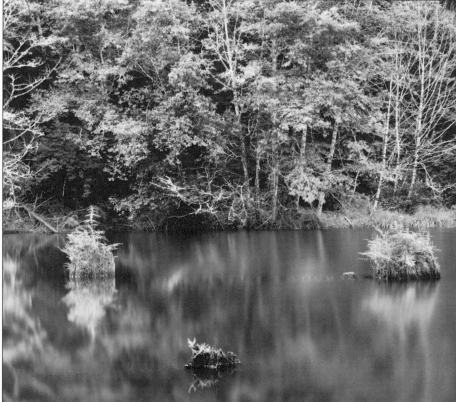

Section 3.2
VISUAL ELEMENTS: LINES

Lines are present in almost every landscape. Examples include the horizontal lines of the horizon, bridges, or clouds; the soft curves of a shoreline, a flowing creek, a country road, or a sand dune; the dynamic oblique lines of receding mountain ranges; or the strong verticals of trees. Although the outline of all shapes are lines, some photographs are thematically dominated by shapes, while others are dominated principally by lines.

Whereas shapes add stability and focal points to a landscape, lines add movement and cohesion. Shapes invite the viewer to stop, stare, and study. Lines ask the viewer to move and travel. The eye will automatically and instinctively follow a line from its starting point to its end. Only then will the viewer scan the remainder of the photograph for detail. The eye will return, however, again and again to the flow of the line as a principle, compositional element. In addition to leading the eye through the scene, lines can act as a strong cohesive force, connecting one shape to another. As a photographer, you have the power to lead the viewer through the landscape in whatever direction you choose. Lines can also be the entire subject in themselves, creating a photograph of intense movement and strength.

The ultimate effect of any lines depends on the actual subject, the shape of the lines, the contrast between the lines and the background, the relative weight of the lines within the frame, and their orientation (vertical, horizontal, diagonal, or curved). Lines are among the strongest compositional tools you have. Experience and observations will help you first to recognize lines in your landscapes, and then to refine your use of them to achieve a tight composition.

High Horizon (horizontal line in upper half of frame)
• Heaviness • Nearness • Earthiness
Centered Horizon (horizontal line in center of frame)
• Static • Quiet • Peaceful
Low Horizon (horizontal line in lower half of frame)
• Lightness • Expansive • Ethereal

Horizontal Lines

A single horizontal line spanning across your landscape acts as a horizon, dividing your photograph into two rectangular areas. Generally, horizontal lines imply distance, permanence, and tranquility. Horizontal lines within a horizontal landscape accentuate the expanse and openness of the scene. Repeated horizontal lines emphasize distance and lead the eye from the bottom to the top of the landscape.

As with any element of composition, these are vast generalities. However, these generalities give you a starting point when studying the effects of lines in landscape compositions.

If you use a single, dominant horizontal line that gives the impression of a horizon, the position of that line within the frame can change the mood of your photograph. The higher or lower in the landscape your "horizon" becomes, the more dynamic the scene becomes.

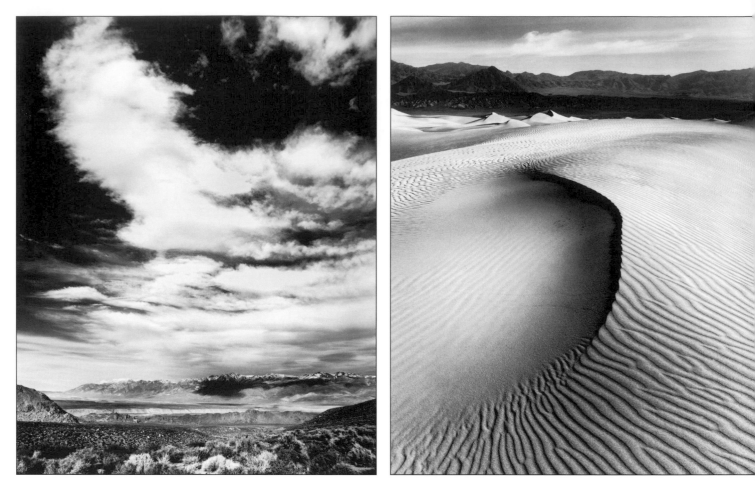

The low horizon in the left photograph creates an ethereal and almost endless quality. In contrast, the high horizon in the right photograph intensifies the earthiness and proximity of the sand dunes. Notice how the lines in the sand lead your eye to the circular, dark edge of the dune. This curve then leads your eyes to the supporting background mountains. Although the circle is only partial, the tonal and textural contrast on its two sides makes it a very dominant focal point.

When the horizon cuts directly through the center of your landscape, your scene splits into two equal halves. Sometimes, this equal division can lead to a boring, overly static composition. In some landscapes, however, a centered horizon can emphasize a landscape's stillness, peacefulness, quietude, and symmetry.

Completely omitting the horizon reduces the impression of depth and the relationship of earth-to-sky, and increases the importance of detail, textures, shapes, and lines. Most landscape scenes include an actual or apparent horizon line. When a scene lacks any suggestion of a horizon, the scene becomes a closer, intimate view, inviting the viewer to study the details carefully. For example, the photograph of trees on page 41 omits any suggestion of a horizon, inviting the viewer to be a more intimate part of the scene.

Vertical Lines

Whereas horizontal lines impart a distant, expansive, and tranquil response to a landscape, vertical lines generally portray a mood of proximity, confinement, and warmth. Vertical lines also reinforce the feeling of height. This effect is exaggerated when the landscape is shot vertically. Additionally, vertical lines seem more likely to bend or sway than do horizontal lines. This tendency makes verticals more transient and fragile. Repeated vertical lines, by creating a visual obstacle, can often highlight the separation of the foreground and the background.

A single vertical line running most (or all) of the way from the bottom to the top of your photograph will divide your landscape into two sections. If this line is wide enough or contrasts enough against the background, you will have created two rectangular spots. The eye will jump back and forth between these two sections. This division may be distracting to your overall theme.

Study the effects of verticals to see how they can strengthen or weaken the mood, visual coherence, and balance of the overall landscape you are composing.

Diagonal Lines

Unlike the rather static nature of both horizontals and verticals, diagonal lines seem to be falling. They suggest movement, tension, and instability. Like triangles, they are one of your most powerful tools for achieving dynamic landscapes.

Two diagonal lines whose ends meet at a point may suggest movement in a particular direction. Additionally, lines that meet or cross will form the apex of a triangle. This apex will draw the viewer's attention as a focal point.

Curved Lines

All curved lines suggest diagonals. As such, they give the impression of movement, rhythm, and change. Tight or erratic curves give landscapes a very dynamic, agitated, or tense feeling. Soft curves, on the other hand, often imply a relaxed but still dynamic mood.

Below Left: The centered horizon creates a calm and quiet mood. The triangular wave of sand briefly interrupts the horizon, adding dynamic interest to this otherwise static scene. As this photograph shows, simplicity and symmetry with just a hint of visual movement can create very powerful yet peaceful landscapes.

Below Right: These repeated, vertical trees and the vertical viewpoint exaggerate the feeling of height. Also note how the repeated trees become lighter and smaller as they disappear into the distance. This type of repetition strengthens our perception of depth in this scene.

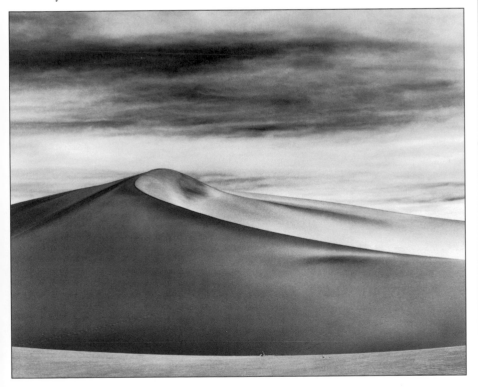

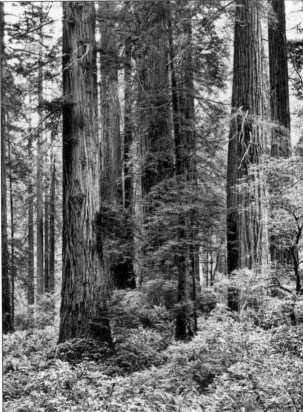

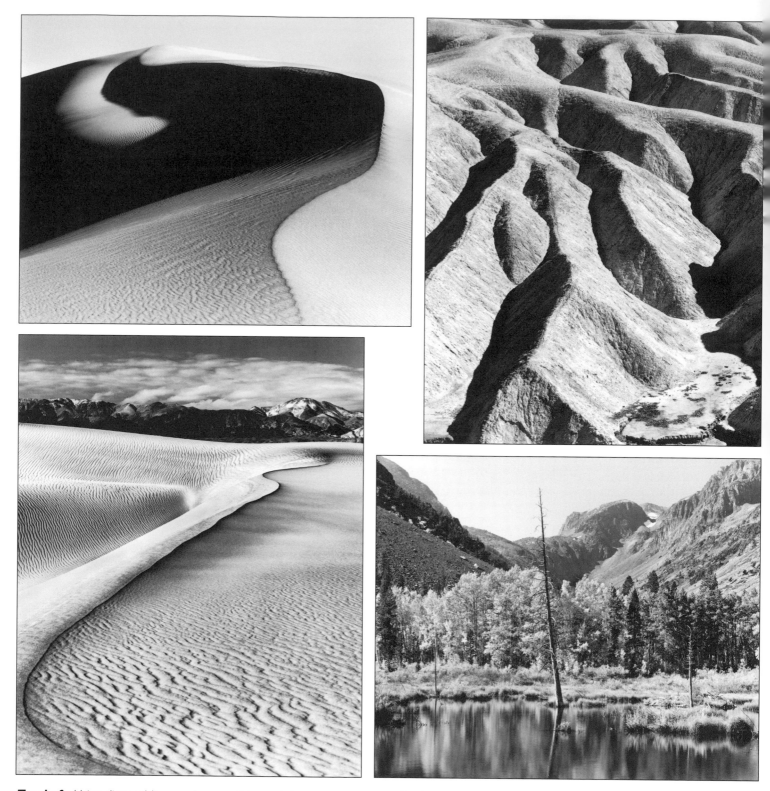

Top Left: Using diagonal lines and curves, this sand dune suggests strong visual movement. The stark tonal contrasts among different parts of the dune create distinct spots, causing the eye to jump from one area to another before following the line up the dune again. However, even with all its visual movement, this scene presents an overall calm and quiet mood due to its simplicity in shapes and textures. Not having anything else but sand in the photograph allows the viewer to concentrate on only one element – the sand dune.

Bottom Left: The harsh sidelight creates a sharply defined curve that leads the eye directly to the background. The width and texture of the curve become smaller, increasing our perception of distance from the camera to the mountains. Unlike sharp, straight diagonal lines, this curved line seems to flow like water.

Top Right: The complex direction and interconnections of these lines creates an interesting, dynamic subject. The contrast in tonalities and the shapes of these lines keeps the viewer's eyes endlessly exploring the scene for detail.

Bottom Right: The single tree in the middle of the scene is confusing and distracting. Is the lake the focal point? The tree? The mountains? Furthermore, this scene, even without the tree, has no clear focal point. Its myriad of shapes, lines, and textures is confounding. Finally, the tree and its reflection form a line that chops the scene into two halves.

Irregular Lines

In nature, the majority of lines are irregular. Of course, the farther away the camera moves from the actual objects, the smoother these lines appear. Because irregular lines consist of diagonals and curves, they suggest activity. Sometimes lines are irregular enough and contrast sharply enough with the background that their shape can be the subject itself.

Concerns

Some lines bind the elements of a photograph and add movement. Other lines are simply distracting. Because lines provide very strong directional flow, you need to control them carefully to avoid leading the viewer away from the subject or completely out of the frame.

Continuation of Lines

Most lines in landscapes stretch much farther than the boundaries of your frame. Just as the mind will automatically attempt to complete partial shapes, it will attempt to continue partial lines beyond the borders of the photograph. This process of continuation creates a much larger virtual scene. These lines help to exaggerate the expanse of the landscape. Also, the viewer becomes actively involved in recreating the entire 180° scene.

Combining Shapes and Lines

The positioning of shapes and lines in a scene can significantly affect its overall mood, rhythm, and balance. For example, a spot positioned near the top of a vertical line reduces the stability of the line. The visual "weight" of the spot appears to bend the line. This illusion adds movement and tension to the scene. The same spot near the bottom of the vertical line increases the

> "Because lines provide very strong directional flow, you need to control them carefully ..."

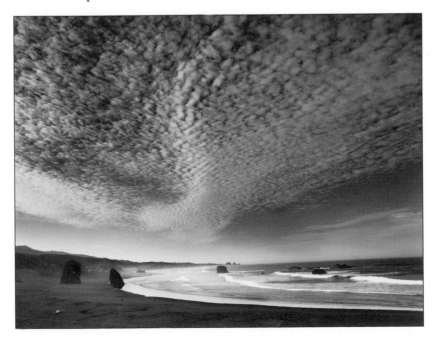

The lines of the horizon, waves, and clouds continue beyond the border, creating a much larger virtual scene in all directions. Also note how these lines all lead the eye to a single, unknown point in the distance. These convergent lines enhance the depth of the scene.

"... shapes and lines can add movement and interest to a landscape."

stability of the line, giving the entire scene more balance and less movement. Similarly, a spot near one end of a horizontal line tends to bend the line down, adding increased movement and tension. Which position you use will depend on your subject and the mood you want to portray.

The combination of shapes and lines can add movement and interest to a landscape. Unfortunately, because of a spot's inherent visual weight, it can offset the balance of a scene. Experience and critical analysis will teach you when a certain combination helps or hurts your overall theme and composition.

Section 3.3
VISUAL ELEMENTS: TEXTURE

In everyday scenes, the difference in color between two objects is often a quick clue to their identity. For example, in a color photograph of a paved road crossing a dirt road, the eye first uses color to determine which road is paved. In a b&w landscape photograph, however, those color clues disappear because many objects can have approximately the same tonal values. The principal element in distinguishing between the dirt and paved roads now becomes their textures rather than their tones. Surface texture, or the "feel" of an object, assumes a much more important role in b&w photography as a means of identifying objects.

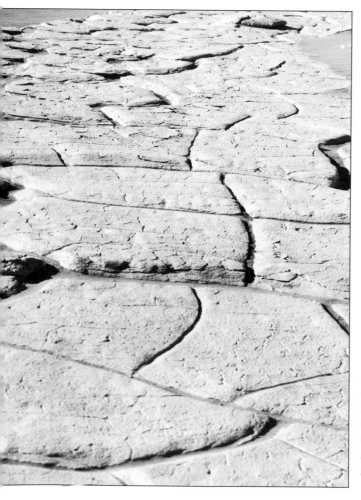

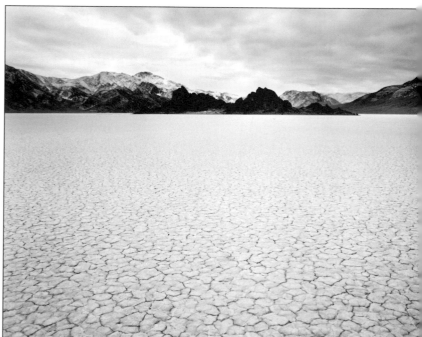

Left: Without a horizon or other objects in the scene, this photograph is a study of texture. Their absence creates an almost abstract view of the land, in which the location and actual dimensions are impossible to determine.
Right: The viewer can almost feel the rich texture of this cracked earth. The high horizon and dominance of this simple, repeated texture give this scene a desolate, earth-bound mood. Note how this texture becomes smaller and smoother as it recedes into the distance, increasing the effects of depth between the viewer and the mountains.

Some landscape photographers create images of textures as the dominant subject. Other photographers regard these textural studies as superficial and feel that compositional themes should be more substantial. Whether you use texture as the overall theme or more traditionally as a visual enhancement is a personal choice.

Many variables affect the texture of a surface. The most important of these variables are lighting, shadows, perspective, focal length, and depth of field. For example, the closer an object appears, the more apparent its textures become. Additionally, looking at an object from one angle may emphasize its texture more than from a different perspective.

Perhaps the most important way in which a texture is exaggerated or subdued is through lighting. "Head-on" lighting (that is, light hitting an object at such an angle that very few shadows occur) minimizes the effects of texture. For example, under the very bright, head-on light of a noon sun, a rock may assume a smooth, almost satin-like sheen. Side lighting, on the other hand,

Functions of Texture

- Texture helps to distinguish objects from each other.
- Texture adds realism.
- Texture adds compositional interest and strength.
- Texture adds three-dimensional form to objects and depth to the entire scene.

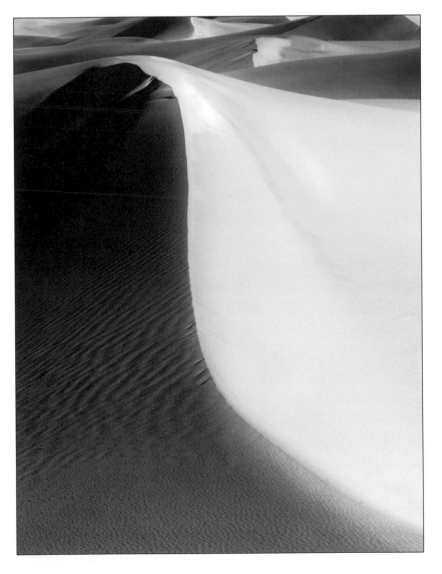

Lighting and Texture	
Front Lighting	Minimizes the effects of texture
Side Lighting	Exaggerates textures
Back Lighting	Eliminates textures while emphasizing the silhouette shape of the object

The texture on the right half, where the sun is head-on, is smooth and almost silky. The left half receives indirect, oblique lighting, which maximizes the rich lines and textures of the sand. The strong contrasts of tonalities and textures, coupled with the dominant curves, create a dynamic, abstract, soft portrayal of the dunes.

exaggerates surface textures. The same rock, when photographed much later in the day, shows a more weathered, craggy surface because of the increased shadows from the oblique lighting.

In addition to the natural textures of landscapes, grain is a very important photographic texture that is a product of film and the developing process. Some photographers intentionally exaggerate a film's grain as a compositional and textural element to enhance the mood of some landscapes.

Colors often define (or even create) a surface's textures. When colors translate into b&w tonalities, some of these textures are subdued or lost. Therefore, seeing and using textures creatively in b&w landscapes is an important compositional skill to develop.

Section 3.4
VISUAL ELEMENTS: REPETITION AND PATTERNS

The sections above highlight the compositional strength of shapes, lines, and textures in landscape photographs. You can often strengthen a composition further by repeating these elements. Repetition will form patterns, which add organization,

The diagonal slopes of the left and right mountains lead the eye directly to the main focal point – the center mountain. The incomplete but obvious triangular shapes of these two side mountains strongly reinforce the dominant subject. The variation in size and lighting among these repeated shapes creates a dynamic composition. The simplicity of the shapes, the uncluttered background, and the low horizon all contribute to the scene's overall quiet, calm mood.

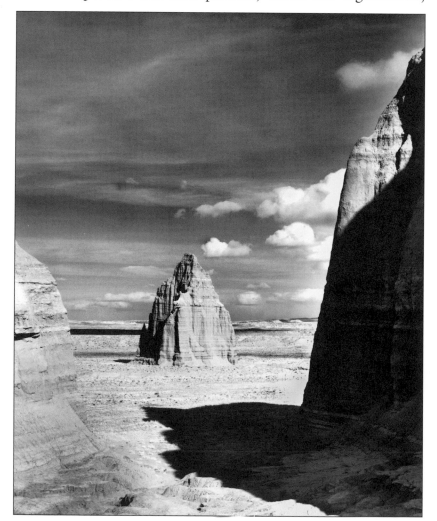

strength, and rhythm to your landscapes. The mind immediately finds and concentrates on repeated objects and patterns. Almost every scene in nature has some degree of repetition. As an artist, you can control how much repetition each scene will have.

As a general guideline, a slight to extreme variation in the repeated elements creates a more dynamic, interesting scene than one in which every repeated element is identical. Fortunately, such variations occur naturally in most landscapes.

Of course, if every scene contained repeated elements with variation among them, your portfolio would soon become monotonous. Some subjects are thematically, tonally, or texturally strong enough to stand by themselves as the main (or only) focal point of the scene.

In other cases, the repeated objects contain very little variation among them. Finding a viewpoint that emphasizes such stark replication could strengthen your statement of that particular landscape.

Be aware that too much repetition or lack of variation can quickly become static and boring for the viewer. Some repetition can add strength and movement to your landscape. Too much can be dull or can detract from your main subject or overall theme.

"... variation in the repeated elements creates a more dynamic, interesting scene ..."

The repetition of these leaves immediately captures the viewer's attention. The slight variation in size, shape, and tonality among the leaves holds their interest and adds movement to the composition.

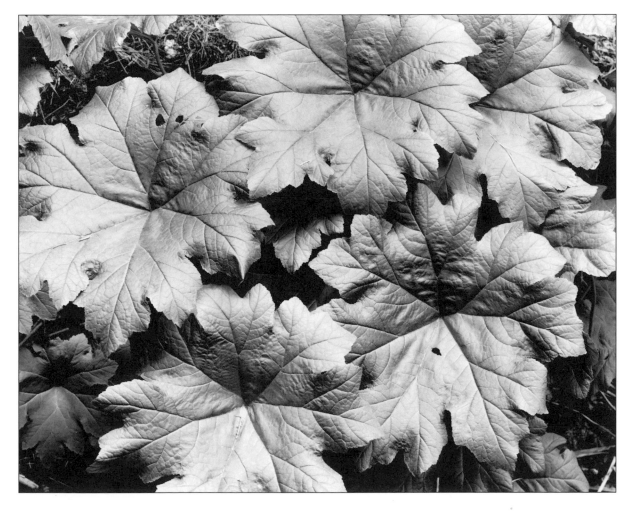

The compositional strength of this scene is a result of similar lines and shapes, and contrasting tonalities. The variation of light and dark areas adds organization and visual movement. The eye continually follows the curves from the foreground to the background and back again, creating strong viewer participation. The inclusion of a small strip of background dunes helps to define the size and depth of the dunes. Finally, the lack of a horizon line imparts a feeling of earthiness and proximity.

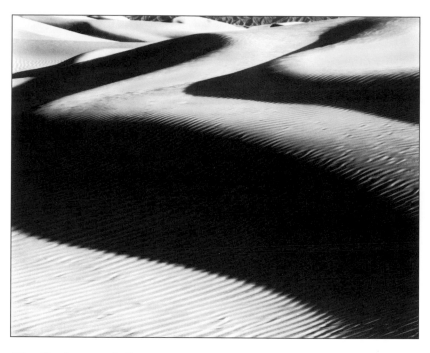

"... similarity helps to bind all the elements of the scene compositionally."

Similarity and Contrast

One of the ways the mind organizes a scene is by looking for similarities. Two or more elements in the scene may be similar in shape, size, texture, or lighting. This similarity helps to bind all the elements of the scene compositionally. In addition, because the eye automatically moves from one element to other similar elements, you create a scene with movement by creating a visual bridge from one element to another. Likewise, elements can starkly contrast with one another in shape, size, texture, or lighting. Just as our mind organizes by similar elements, it also uses comparison and contrast to interpret the scene.

Both similarity and contrast are excellent compositional tools to create thematic unity and visual movement in your landscapes. As with any compositional technique, similarity and contrast will not always strengthen every scene. They should be used to reinforce your point of view, not merely as compositional tricks.

Combinations

Very few landscape scenes consist of lines (or shapes or textures) exclusively. Instead, most scenes have a natural combination of these elements. Line, shapes, textures and tones interact with all other elements. Certain combinations strengthen the scene by adding visual movement; others weaken the scene by detracting from the overall theme.

An important skill is finding the most appropriate type, number, and placement of elements within the scene. Combinations, no matter how subtle or stark, create relationships that add rhythm, movement, organization, and interest. Ultimately, the relationships among the elements of a landscape are far more important artistically than are the elements themselves.

Section 3.5
FRAMING

An often used, sometimes overused or inappropriately used, technique is partially or completely surrounding your main focal point with another object. Just as the photograph's borders frame the entire scene, objects within the scene can frame other objects. Framing can strengthen the photograph by directing the viewer's eye immediately to the point of interest in the scene. The frame can be almost any shape; however, the shape of the frame should complement, not detract from, the main subject in the landscape.

Most importantly, the framing object should be closely related or significant to the main object. For example, a massive tree running up the left side of the frame and spreading across the top of the photograph to frame a distant mountain range actually weakens the image. The foreground trees have no direct literal or compositional relevance to the mountains. Conversely, if the mountains extended to the foreground and you could partially frame the distant range with foreground rocks, similar shapes, tones, and textures would strengthen the image.

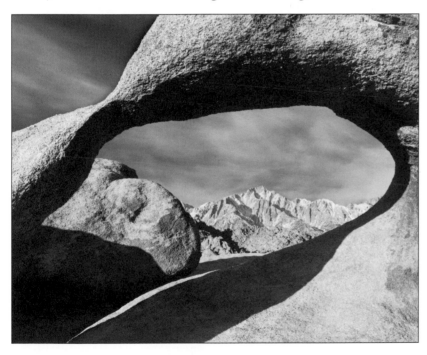

The foreground arch effectively frames the distant mountains. Both elements are thematically and texturally related. The overall simplicity of the scene, coupled with the contrast of circular and triangular shapes, makes this image compositionally strong.

Section 3.6
PHOTOGRAPHIC VISION

How many times have you photographed the "perfect" scene, only to be very disappointed when you see the finished print? You just know that the original scene looked much better than your photograph shows. What happened?

Photographic vision is the ability to look at a scene and determine if it is a good candidate for a photograph. This ability is extremely important for creating fine-art landscapes. Some land-

"... turn a mediocre 'real-life' scene into an outstanding photographic image."

scapes are inherently photogenic, but some are not. Combining years of experience, books of compositional techniques, and extensive darkroom manipulations, even the best photographers cannot squeeze excellent photographs from some scenes.

However, your photographs will improve by understanding the differences between the original scene and the scene actually recorded on film. Your ability to see the actual landscape as a photographic landscape will improve. Also, you will be able to decide if a particular scene (although it looks great while you are standing there) will not be as impressive in the final photograph. Most importantly, you will be able to exploit these differences to your advantage and turn a mediocre "real-life" scene into an outstanding photographic image.

Vision

When you view a landscape using both eyes, the images recorded by each eye are slightly different. The closer an object is to you, the more noticeable this effect becomes. For example, suppose you are photographing a desert landscape. In the foreground, just a few feet from you is a large stone. While staring at the background through the left eye only, then the right eye only, you will notice how the foreground stone appears to shift its position left or right. This slight difference in perspective is due to the distance between our eyes. It adds an important left-to-right perspective realism to the scene, known as stereopsis.

Unfortunately, this stereoptic effect is lost in the final photograph because the camera's single lens records the scene through only one lens, giving a perspective called monopsis. Although you cannot correct this difference, you can increase the illusion of the original perspective. If the left and right sides of the foreground objects have different lighting, shadows, textures, or shapes, the mind is more likely to perceive more three-dimensional depth in the photograph.

Experiment with different foreground objects under diverse lighting conditions. When you analyze the final photographs, you should be able to see which effects create the most "realism."

	Actual Vision	Photographic Vision
Vision	Stereoptic	Monoptic
Color	Color spectrum	B&W spectrum
Senses	Five	One
Space	Unrestricted	Restricted
Analysis	Unnecessary	Necessary

Understanding and controlling the differences between the actual, full-colored scene and the final b&w print will improve your photographic vision.

Color

Obviously, the real-life scene is in full color. Although color is one measure of the landscape's beauty, translating a color scene to one rich in b&w tonalities is a measure of a landscape photographer's skill. Many of the greatest photographers during the last fifty years have worked exclusively with b&w films.

The mastery of seeing a scene in color and translating the scene into b&w takes experience and thought. By comparing the various shades of gray in a b&w photograph with the actual colors in the scene, you will improve your b&w vision.

If possible, take two cameras (one loaded with b&w film and the other one with color film) to your favorite landscape location. Photograph the same scenes using both cameras. By analyzing the tonal differences between the b&w and the color versions, you will learn how to translate in your mind between the two.

The use of filters (Section 4.2) can lighten or darken certain shades of gray by using the knowledge of how color translates to gray, and by carefully selecting filters, you can create very dramatic b&w landscapes.

Senses

Perhaps the most important and most common reason that majestic real-life landscapes become disappointing photographs is the reduction in senses. In the actual scene, all of your senses are contributing to its impact. You first see the gorgeous, expansive mountainscape with a brilliant sunset. You hear the wind rustling the leaves, and you smell the intense fragrances from the surrounding flowers. Additionally, you feel the cool wind and light spray of mist blowing off the river, and you feel and hear the rocks and leaves under your feet. Combined, these elements form your impression of the scene.

Unfortunately, later in the darkroom, the photograph does not seem as vibrant and dramatic as the original scene. Now only one sense (vision) must contribute to the viewer's reaction to the scene.

As you are composing your photograph, the ability to ignore all senses except vision is critical. Analyze your landscape photographs. Are they as exciting as the actual scene? If not, perhaps the composition or lighting was weak. Perhaps, though, by using all your senses, your mind originally created the impression of a scene that could never have been effective with sight alone.

Ignoring our other senses is very difficult and almost unnatural. This skill, however, is necessary to create a photograph that is powerful (or even more powerful) than the original landscape.

Space

An actual landscape is unlimited in all directions. The scene has a feeling of almost infinite expanse and openness. However,

> "... translating the scene into b&w takes experience and thought."

"You can apply several techniques to create the illusion of a much larger landscape."

the final photograph offers a restricted, bordered view. A large part of the original scene's drama resulted from that unconstrained view. When your photograph displays only a small portion of the 360° original view, it may seem less impressive.

You can apply several techniques to create the illusion of a much larger landscape. When shapes, lines, shadows, textures, and patterns run beyond the borders of your photograph, the mind automatically attempts to continue or complete them. This continuation creates a larger "virtual" scene in all directions. Also, as the size of your photograph increases, the objects appear more and more as they did in the original scene. The impact and openness of a 20x24 inch landscape print is far greater than a smaller print of the same scene. An important skill that you will develop through experience is knowing which of your smaller prints are good candidates for very large photographs.

Analysis

In the field, anywhere you look is the "final result." Viewing is spontaneous, and the scenes do not require any technical, analytical, or compositional thought. Your task is to translate a stereoptic, full-color, all-senses, unlimited view into a monoptic, b&w, vision-only, full bordered landscape. Therefore, you have a much greater need to analyze the scene thoroughly. This analysis must occur from both a compositional and a technical perspective in order to produce a photograph as dramatic and visually perfect as the original.

Although you might lose some spontaneity by taking the time to compose the scene, you will gain enormous artistic control and flexibility. With experience, your skills will improve at recognizing, compensating for, and taking advantage of the differences between actual vision and photographic vision. Your landscape photographs will eventually reach the point where they appear more dramatic and beautiful than the original scene.

Five Ways to Change the Viewpoint

- Choosing a horizontal or vertical film orientation
- Moving closer toward or farther from the subject
- Moving the camera left, right, up, or down
- Changing the focal length of the lens
- Adjusting the lens plane or film plane of a large-format camera

Section 3.7
VIEWPOINT

Viewpoint is the portion of the scene that the camera records on the film. A combination of film orientation, camera position, and focal length allows you almost unlimited viewpoints for every scene. Choosing the one most suitable for the particular subject and mood requires careful analysis and experience.

Horizontal or Vertical?

The choice of whether to position your camera horizontally or vertically is, like all other compositional elements, purely subjective. In general, the two orientations emphasize different traits. A horizontal frame emphasizes, of course, the horizontal

elements in the landscape, such as the horizon itself, a mountain range, or a winding coastline. It suggests left-to-right expanse and often suggests a cool, relaxed, and tranquil view of the landscape.

A vertical orientation, on the other hand, exaggerates any vertical elements in the landscape, such as tall trees, canyon walls, or waterfalls. This format conveys compression and proximity to the viewer. It also portrays a more intimate view of the scene than does a horizontal view.

Just because a landscape scene contains predominantly horizontal elements is not a reason, in itself, to choose a horizontal format. Photographing this scene vertically may result in a very different mood. Study the works of landscape masters to understand why they chose a horizontal or a vertical format for a particular scene.

The horizontal orientation of the lake emphasizes the left-to-right expanse of the land and creates a calm mood. In contrast, the vertical orientation of the waterfall exaggerates its height. Omitting any suggestion of a horizon helps to pull the viewer into the scene.

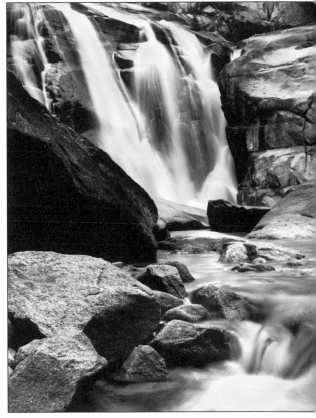

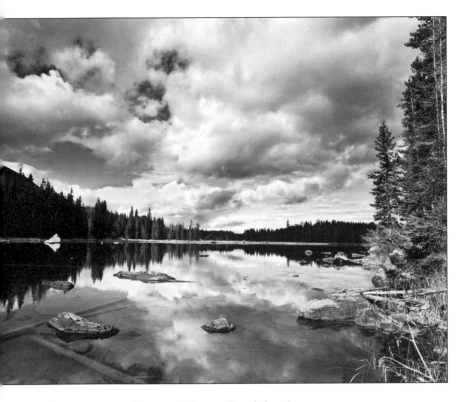

Camera and Lens-Plane Positioning

The exact position of your camera is critical for creating the most ideal viewpoint. Often, moving your camera just a few inches can transform a good landscape scene into an excellent one. First, you can frequently increase viewer interest in the landscape by positioning the camera so that lines, shapes, light, shadows, and textures form the strongest composition. Also, by adjusting the camera position, you can often eliminate any distracting foreground or background objects, such as intrusive branches or rocks.

Study the four borders in your viewfinder to see what lines and shapes are leaving the scene. Look at the position of any lines

(or shapes) that are suggesting movement. Adjusting the position of those lines within the frame can often reinforce their directional aspects and direct the viewer's attention to the subject.

On large-format cameras, the photographer can adjust the lens plane and the film plane independently. This flexibility permits greater control over the perspective. Sometimes a slight adjustment will result in a better viewpoint.

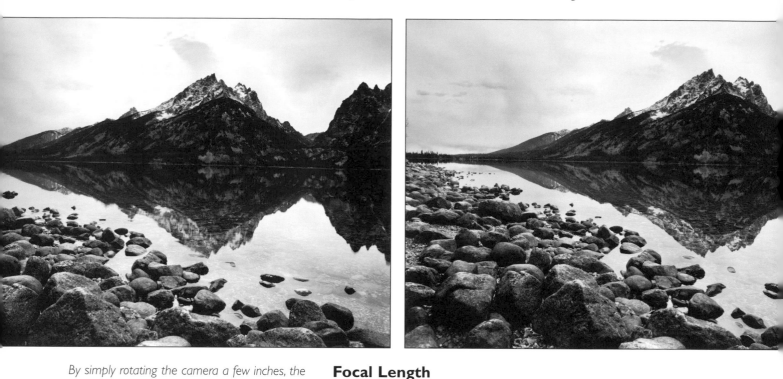

By simply rotating the camera a few inches, the weak photograph on the left became the much stronger image on the right. In the left photograph the mountain peak protruding into the right edge of the frame is distracting and serves no compositional purpose. Eliminating that spot strengthens the viewpoint by simplifying the dominant focal point.

Focal Length

Changing the focal length directly affects the viewpoint by changing how distant or close the subject appears, and how much of the landscape the film "sees." If you want to include more landscape in your viewpoint, you have two choices. You could physically position your camera farther away, or you could instead use a shorter focal length lens. However, these two methods will produce different viewpoints.

Likewise, if you want a closer view of the landscape, you have two choices. You could position your camera closer to your desired scene, or you could use a longer focal length. Again, these two methods will produce different viewpoints.

Obviously, physically moving farther from or closer to the point of interest may be impractical or impossible. Your only choice then would be a wide-angle or telephoto lens. Changing the focal length affects several factors in the scene.

Wide-angle lenses decrease the apparent size of background objects and increase the size of foreground objects. These lenses increase front-to-back depth by separating objects that may actually be close together. Wide-angle lenses also increase the feeling of openness.

	Wide-angle Lenses	Telephoto Lenses
Foreground objects	Larger than normal	Smaller than normal
Background objects	Smaller than normal	Larger than normal
Relationship of foreground objects to background objects (degree of compression)	Increases front-to-back depth (reduces compression; expands the scene front-to-back)	Reduces front-to-back depth (increases compression; contracts the scene from front-to-back)

Telephoto lenses produce exactly the opposite effects by increasing the apparent size of background objects. These lenses compress the depth from foreground to background by crowding objects that may actually be far apart. Telephoto lenses reduce the openness of a scene.

Anytime you photograph a landscape using either a wide-angle or a telephoto a lens, you create a scene somewhat removed from reality. The large range of available focal lengths allows you to control how much landscape is included in the scene, the front-to-back depth, compression or expansion of distance among objects, and the overall mood of the scene.

The focal length of a lens changes not only how much of the scene fills the frame and how large distant objects appear but also alters the depth relationship among foreground and background objects.

Adjustments in the Field or Darkroom?

Most photographers, at some point, have asked these logical questions: Why worry too much about finding the "perfect" viewpoint and exactly the right focal length? Why not just photograph every scene using a wide-angle lens and then enlarge and crop the scene in the darkroom?

If all lenses, focal lengths, and films could produce infinitely perfect sharpness and resolution, infinitely small grain, and precisely the same perspective, then the above method would be possible. Unfortunately, as you increase the magnification of the final print, the sharpness and resolution of distant objects deteriorates rapidly. Similarly, the distance between the grains of silver increases as the size of the enlargement increases. Because increased grain causes reduced sharpness and overall contrast, using the darkroom enlarger as a compositional tool is a weak method. Finally, the previous section details the visual differences between a wide-angle scene and a telephoto scene.

Sometimes because of rapidly changing light or weather conditions, you will not have the luxury of unlimited time to compose the scene carefully in the field. To avoid losing the photographic opportunity altogether, you should quickly photograph the scene with a normal or wide-angle lens. If the conditions worsen and that single shot is all you have, you can sometimes "compose" the scene in the darkroom by enlarging and cropping. However, this method is a very weak approach to landscape composition because it introduces increased grain, reduced sharpness,

"... a skilled photographer visualizes how the final print should appear ..."

lack of spatial control and depth, and lack of overall compositional control and creativity.

Therefore, in all but the most extreme and unavoidable cases, you need to compose the entire scene exactly (or nearly exactly) as you want it to appear in the final print. Becoming an excellent landscape photographer is not a matter of clicking the shutter on a beautiful scene and hoping to make it look acceptable in the darkroom. Instead, a skilled photographer visualizes how the final print should appear, carefully composes the scene, controls contrast and tonalities during the exposure, and reserves the darkroom for enhancing what is already there.

Section 3.8
DEPTH AND SIZE

Depth – the apparent distance from the closest to the most distant objects – serves two main functions. It helps the viewer to judge the relative size of objects more accurately. For example, if you photograph a rock at very close range, the viewer may not be able to discern how large this rock is or how far away from the camera it is. Depth also increases the expansiveness and three-dimensional realism of the scene.

The inclusion (or exclusion) of foreground, mid-ground, and background elements greatly contributes to the overall depth. Additionally, the relationship of these elements (their positioning, size, lighting, focus, and degree of compression) affects the perception of depth. For example, a tree can appear larger or smaller depending on the position and size of other objects in the foreground or background.

Depth Cue	Effect as Object Recedes into the Distance
Linear perspective	Parallel lines converge to a point. To exaggerate, use a wide-angle lens.
Size diminution	Objects of similar size appear smaller.
Texture gradient	Similar textures become smaller and denser.
Aerial (spatial) perspective	Due to the atmosphere (haze, mist rain, etc.), objects become lighter, less sharp and have less contrast. To exaggerate, use blue filter; to reduce, use polarizing, deep yellow, orange, or red filter.
Lighting & shadow perspective	Shadows help the viewer to judge distances more accurately, as well as increase the perception of depth. Lighter tones usually recede into darker tones.
Overlap	Foreground objects partially obscure the view of more distant objects, increasing the perception of depth.
Familiarity	The viewer's memory and experiences with sizes and distances improves the accuracy of apparent depth in the scene.
Upward perspective	Objects farther away from the viewer are higher in the frame of view. To exaggerate, use a low camera position and include foreground elements in the landscape.

When the mind analyzes an actual scene in a photograph, it uses eight important cues to determine the depth and the relative size of objects. These visual cues are listed on page 56 with their effects on receding lines and objects. Not every photograph will (or should) include all these cues. However, learning to recognize and manipulate these cues will help you to achieve a much greater depth and three-dimensional impact in your landscapes.

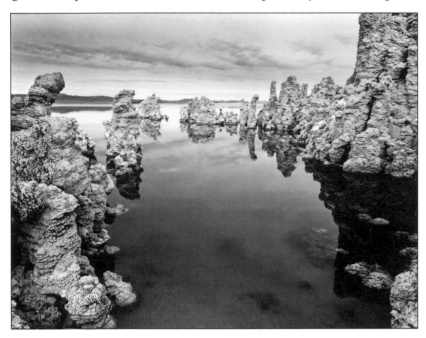

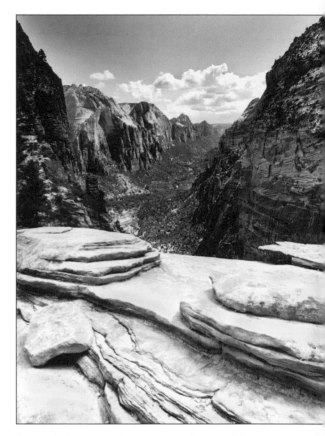

Section 3.9
TONALITY AND LIGHTING:
THE PHOTOGRAPHER'S PAINT

Just as a writer's medium is language and a painter's medium is paint, a photographer's medium is light. An artist's goal is to study, interpret, and control this medium to complement the subject and to create a unique point of view. Unquestionably, light is the photographer's most important technical, compositional, and artistic tool. It is, in a sense, the very basis and life of a photograph.

Photographers in most disciplines have the option of using and manipulating artificial lights in addition to using any natural light. Landscape photographers, conversely, must create spectacular scenes using only natural light. If the lighting is weak, too strong, in the wrong location, or striking at the wrong angle, the landscape artist cannot manually change it. However, you can often enhance the effect of the lighting to strengthen the theme of the photograph and to create a more dramatic image. Very often, the biggest difference between a good landscape photograph and an excellent one is the expertise of recognizing, designing, and controlling the effects of light.

In the left image, the texture and size of the tufas decrease in the distance (size diminution and texture gradient). Also, the imaginary lines formed by the tips of these tufas converge (linear perspective). The combination of these three cues increases the depth of the scene. The right image uses five cues. Foreground canyon walls on both sides of the frame hide part of the distant canyon (overlap). The diagonal lines of the canyon walls and of the canyon itself converge (linear perspective). The texture and size of the foreground rocks and canyon walls decreases in the distance (size diminution and texture gradient). Finally, the canyon walls become lighter in tonality the farther away in the distance because of atmospheric haze (aerial perspective).

"... light is the landscape photographer's single most useful tool for creating mood."

Light has several important purposes for landscape photographers. First, it can lead the viewer's eye to one or more specific areas of the scene. Light also creates shadows and gradations of tone, which in turn transform two-dimensional objects in photographs into richly textured three-dimensional objects. Light itself can create lines, shapes, and complex designs. Even a slight change in the lighting can change the entire composition. Light can offer the viewer important cues about depth and the proximity of objects.

Finally, and perhaps most importantly, light is the landscape photographer's single most useful tool for creating mood. Identical subjects can assume remarkably different feelings under different lighting situations. Lighting becomes your paint. Experience and concentrated vision will enable you to create, in a sense, a landscape by "painting" with light.

Most beginners in landscape photography spend too much time studying the subject and not enough time studying the light. Light allows you to communicate what portions of your scene are the most important, which are not, and the overall, intended mood of the photograph. Therefore, a clear understanding of light is imperative to create fine-art landscapes.

The following sections discuss the most important elements of light as they concern landscape photographers: how colors translate into b&w, highlights and shadows, contrast and tonalities, types of light, the effects of weather and time of day, and darkroom adjustments.

Like all other topics related to landscape composition, the study of light is complex and unending. More importantly, design concepts are subjective. As you develop experience with landscapes, you will also develop your own vision of light. The way you see and represent light will be like no one else. Light offers an incredible range of artistic freedom.

Section 3.10
TONALITY AND LIGHTING: TRANSLATING FROM COLOR TO B&W

One of the biggest challenges for b&w landscape photographers, in addition to seeing photographically, is visualizing the scene in b&w rather than in color.

Physical Translation

The translation of colors into b&w tones is not an obvious one. Whereas red and green are obviously quite different colors, they can become nearly the same shade of gray in a b&w print.

As an example, an actual landscape scene may have green foliage as the foreground, a deep blue lake as the mid-ground, and rich brown mountains in the background. The scene's

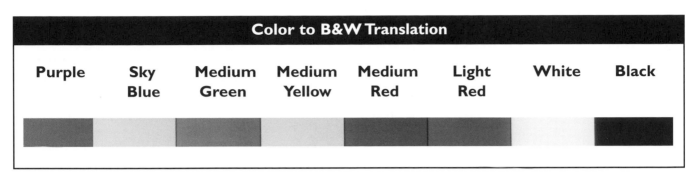

Color to B&W Translation							
Purple	Sky Blue	Medium Green	Medium Yellow	Medium Red	Light Red	White	Black

vibrant colors are breathtaking. Unfortunately, these particular shades of green, blue, and brown may translate into nearly the same shade of gray. The foreground, mid-ground, and background were clearly separated in color. Now they blend together into a confusing, uninteresting photograph. The contrast and depth in the scene was lost due to the translation of color to b&w.

Therefore, an understanding of how b&w film records color will help you to pre-visualize the final result. You will also be able to use filters and the Zone System to control and enhance the actual b&w tones and contrast in your landscape photographs.

Psychological Translation

Most people interpret colors similarly. Warm colors (reds, oranges, yellows) often portray cheerfulness, aggression, proximity, and movement. Cool colors (blue-greens, blues, violets), usually evoke the opposite reactions of sadness, calmness, expanse, and rest. The medium colors (greens, purples) represent a psychological neutral point between the warm and the cool colors. Of course, one person's psychological and physiological reactions to different colors will not be the same as those of another.

Overall, however, a photograph featuring warm colors will evoke a different reaction from most people than a similar landscape containing mostly cool colors. This difference is important for b&w photographers to learn. When colors translate into b&w tones, how will the viewer's emotional reactions change?

Just as warm and cool colors generally evoke somewhat predictable emotional responses, gray tones evoke similar responses. In b&w, lighter shades of gray, as well as white, usually produce the same feelings as the warm colors. The darker shades of gray including black usually evoke the same reactions in the viewer as the cool colors. Finally, the medium shades of gray (the neutral shades) best represent the medium colors.

What the Film Sees

If the film recorded a scene precisely as you saw it, visualizing the final result would be easy. Unfortunately, what you see is not always what the film records.

The film records tonalities objectively as they actually are. The eye, however, views the scene subjectively. Your mind tells

This strip of eight colors clearly shows that the translation from color to b&w is not an obvious one. Blue and yellow, although very distinct hues in color, translate to a similar gray tone in b&w. The tonalities of green and red are also much closer in b&w than they appear to be in color. As you become more familiar with the translation of color to b&w, you will improve your ability to selectively alter these tonalities using a combination of filters and the Zone System.

> "The color you see in your mind is inconsistent with the b&w tone you see in the final print."

you that snow is white. Even during early sunrises or twilight, when the snow may assume a deep blue cast, you psychologically "see" it as white. Color film sees it more honestly, as deep-blue snow. Similarly, b&w film records the actual intensity of the light and records the snow as a medium-dark, dull gray. The color you see in your mind is inconsistent with the b&w tone you see in the final print.

Similarly, certain leaves under a bright sun will reflect most of the light. Even though you still "see" green leaves, b&w film will record very light gray or white leaves. The final print looks wrong. As a final example, b&w film is more sensitive to blue light than to red light. An intense blue sky with brilliant white clouds may appear as an all white sky in the final b&w print.

Fortunately, b&w photographers can use a wide range of filters and the Zone System to compensate for these tonal differences between the eye and the film. Sections 4.2 and 4.3 present the details of these techniques.

Section 3.11
TONALITY AND LIGHTING: THE PHOTOGRAPHER'S PALETTE

In nature, infinite spectrums of colors define, delineate, and give character to the landscape. Experience and memory have ingrained the mind with "acceptable" colors. A brown, reddish, or gray rock is acceptable, but a purple one is not. Of course, photographers creatively push the limits and norms of color using special films, filters, and developing techniques. However, the photographer who wants to maintain realism in the landscape usually strives to reproduce the color spectrum as accurately as possible.

A painter can also create a palette of infinite colors by combining different paints. Unlike the color photographer, the painter can decide artistically exactly which shade of color to paint every object in the landscape.

Similarly, the b&w landscape photographer has an infinite spectrum of gray tones, from pure black to pure white. This palette of grays offers the photographer the greatest expressive and compositional freedom. A landscape image in b&w is, in a sense, removed from reality.

Whereas a color photographer cannot change the sky from light blue to dark green and still maintain realism, the b&w photographer can realistically "paint" the sky almost any shade of gray. Using a combination of films, filters, the Zone System, printing papers, and development techniques, the b&w photographer can choose where in this gray spectrum the landscape elements will lie.

The Spectrum of B&W

The infinite palette of colors in the original landscape translates into an infinite spectrum of b&w tones. Using this palette of grays, the b&w photographer can "paint" a landscape by controlling tones with filters and the Zone System.

Contrast

The relationship between any two tones, or among all the tones in a scene, determines the scene's contrast. Whereas the darkness or lightness (density) of any gray tone is measurable and therefore objective, the contrast between two tones is subjective. Contrast is a psychological and physiological reaction to the relationship among tones. The mind reacts very differently to a scene with a narrow range of gray tones than to a similar scene having a wide range of tones. Likewise, a low contrast landscape evokes a very different feeling than the same scene portrayed in high contrast. The three key relationships among tones that determine contrast are range, number, and position.

First, the greater the difference between the darkest and lightest tones, the greater the overall appearance of contrast in the scene. For example, a dark rock on nearly white snow has higher contrast than a medium-dark rock on medium-light sand. The more transitional gray tones you include between the darkest and the lightest objects, the less contrast the scene will appear to have. Several gradations of medium gray in a landscape of blacks and whites will reduce the scene's overall contrast.

"Contrast is a psychological and physiological reaction to the relationship among tones."

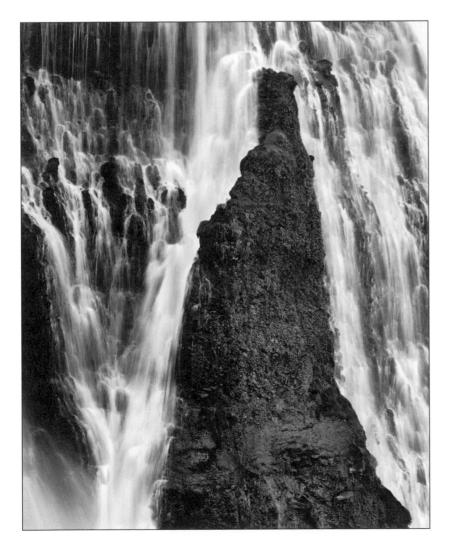

The strong contrasts of tonality, textures, and shapes make this view of a waterfall visually dramatic. The main focal point (the rock) is compositionally dominant because of its large, simple, triangular shape, its craggy texture against the silky water, and its overpowering, dark tone against the light gray water. Note how the vertex of the triangle, the vertical orientation of the camera, and the strong vertical lines in the water all emphasize the enormous height of this waterfall.

Low Contrast or Dark Tones	High Contrast or Light Tones
• Soft, passionate, understated, weak	• Harsh, indifferent, dramatic, powerful
• Quiet, serene, calm, somber, contemplative	• Noisy, violent, agitated, cheerful, vacuous
• Pessimistic, hopeless, hidden	• Optimistic, hopeful, exposed
• Restricted, confined	• Free, expansive

Although every viewer forms an opinion about a landscape based on memories and experiences, similar reactions to low or high contrast is fairly common. The landscape photographer can use these somewhat consistent reactions to evoke a certain mood about an image from the viewer.

Finally, the relative position of one tone to another will change its apparent contrast – and even its perceived tone. A light-gray fern, for example, directly next to a dark-gray tree trunk appears to have higher contrast than when the two objects are separated by medium grays. Also, a medium-gray fern appears lighter in tone directly against a dark-gray tree trunk but darker in tone directly against a light-gray tree trunk.

Therefore, our perception of the actual density of tones as well as the apparent contrast among them changes based on the range of tones in the scene, how many different gray tones are present, and which tones are next to other tones.

Sometimes, strong contrast is ideal, but at other times it can be distracting. Very low-contrast renditions of some landscapes are stunning and appropriate for the mood and reaction the photographer wants. High contrast may work well for other scenes to express the artist's feelings. Beginning photographers often feel (or have read) that the contrast in every scene should be high – pure whites, pure blacks, and a very wide range of gray tones. This idea is not only incorrect but also compositionally limiting and may be difficult to achieve due to lighting constraints. Some of the world's finest landscape photographs contain a very narrow range of tones. Learning to match the tones and contrast in a scene with your feelings and reaction to the scene is more creatively important than blindly following a set of rules. As an artist with an infinite palette of grays and an infinite number of contrast relationships, you should use a contrast range that will best suit your artistic needs.

Control Over Contrast

Tone and contrast, as integral components of light, are the "paints" of b&w photography. Controlling them creatively is one of the most important compositional and technical skills you will develop. The final landscape print is a personal expression. It should reflect your own feelings and interpretation of the scene. You have the artistic freedom to alter the tonalities and the contrast of any scene by any degree you want.

The subject itself may be low or high contrast. For example, the contrast between dark pine trees against a background of snow is very high. You can sometimes soften the overall scene simply by including other objects. Conversely, you can increase the contrast of some scenes by including fewer objects with transitional tones. By altering the angle of view or focal length, you can include or exclude certain objects in the landscape in order to reduce or increase the overall contrast.

The angle and intensity of the light can dramatically alter both the tonality of objects in the scene as well as the overall contrast. Photographing the same scene under different lighting conditions or using filters (Section 4.2) will result in a different look.

The type of film, the developer chemicals, and the length of development can also affect the range of tonalities, the shift of tonalities of individual objects, and the overall contrast. Every manufacturer's film and chemicals produce different results. For this reason, the choice of films, chemicals, and development processes is an individual, artistic choice and may change depending on the particular scene or mood you wish to portray. Many excellent texts (see Appendix B) are available that explore the artistic and technical aspects of altering tones and contrasts using films and development.

Perhaps the most important method to learn in order to control the scene's tonalities and contrast is the Zone System, popularized in the 1940s by Ansel Adams and Fred Archer. The Zone System is both an artistic tool and a scientifically accurate technical tool for controlling tonalities and contrast. The Zone System is an important artistic technique because it allows you to assign certain tonalities to certain objects. It also allows you to adjust the relative contrast of the scene. The Zone System consists of four stages: pre-visualization, metering, exposure, and film development (Section 4.3).

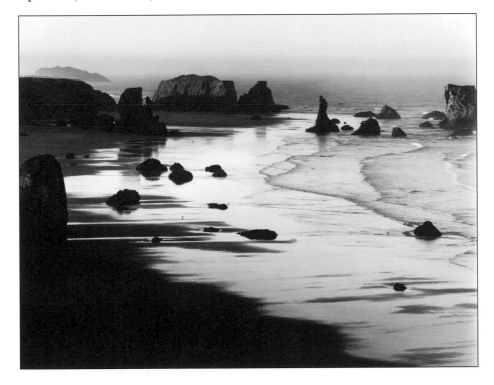

Although largely subjective, viewers often interpret certain combinations of tones and contrast levels similarly. This winding coastline before sunrise contains mostly dark and medium grays and a narrow contrast range. For most viewers, this scene is more mysterious, introspective, and serene than the same scene in bright sunlight.

Highlight and Shadow Densities

The highest and the lowest portions of the b&w tonal range correspond to highlight and shadow tonalities, respectively. Highlights are the brightest areas in the scene. They are not pure white, but very light gray with slight texture and detail. Similarly, shadows are the darkest areas in the scene, and may or may not be actual shadows cast by strong, side lighting. These areas are

"... highlight and shadows are among the most important compositional and technical topics ..."

Photograph

photo = light
graph = to write or draw

not pure black, but very dark gray and contain noticeable texture and detail.

Both highlight and shadows are among the most important compositional and technical topics in landscape photography. They both help to create the impression of three dimensions by emphasizing shading, texture, and depth. Additionally, shadow and highlight areas themselves are shapes. They can attract or direct the viewer's eye. They can add dynamics to a scene or balance the scene compositionally. A landscape print showing weak shadow densities and lacking strong highlight densities can result in a flat, lifeless scene. Creating a photograph that contains deep shadows and rich highlights (both of them rich with texture and detail) is the goal of every fine photographer.

Of course, some landscapes may not have any tones at all in the highlight region, the shadow region, or both. If such a scene with a narrower range of tonalities best expresses your artistic intention, then such a representation is ideal. Generally, however, the majority of landscape prints contain both shadow and highlight tonalities, as well as a wide range of grays between.

Section 3.12
TONALITY AND LIGHTING:
LIGHTING

Most people see objects, but photographers see light. In fact, the word photograph means "to write or draw with light." Until you understand the compositional importance of light, you cannot understand or masterfully express your subject. The objects in the landscape merely create a foundation – something to look at. Lighting, however, creates the interest, the dynamics, and the mood of the scene. If you change the direction, type, or intensity of lighting, and you will change the overall intensity and feeling of the scene. Light, perhaps more than any other single aspect of composition, has the ability to transform the scene.

Light can be an active element of a landscape by creating strong rays of light, bright highlights and deep shadows – adding brilliance, dynamics, and drama to the subject. In some landscapes, active lighting can be used as the primary subject itself. Light can also be passive, such as soft, diffused lighting. Such lighting may be ideal to light the subject evenly or to reinforce a tranquil, soft mood in the landscape.

Learning to see light and its effects on the subject, the overall contrast, the tonalities, and the balance of the entire scene is the most important skill that you will develop as a photographer. The lighting should reinforce and strengthen your personal feelings about the landscape, not weaken it.

The three factors having the strongest impact on landscape lighting are the weather, the season, and the time of day. They

directly influence the direction, intensity, and quality of the light. Unfortunately, photographers have no control over the weather. They can, however, choose the time of day or the season best suited for the landscape scene and the mood they want to express. No rules exist for the best time of day or weather conditions to photograph landscapes. However, every changing lighting condition carries compositional and technical advantages and disadvantages. As you gain more experience, you will learn how to use more and more diverse weather and lighting conditions to compose a landscape photograph. Perhaps the factor most affecting the contrast, shadows and highlights, and mood of the scene is the type of light: direct or indirect.

Direct Light

Light is directional on a clear, sunny day. This type of light increases contrast by creating deep shadows, bright highlights, and a very broad range of tonalities. In the early morning and late afternoon, light strikes the landscape from the side, offering the greatest contrast and shadows. This strong combination produces very rich textures, which emphasize the three-dimensionality of objects. For example, when the sun is directly overhead, a lake can appear to be smooth and two-dimensional. Strong directional light from an early or late sun, however, emphasizes jagged ripples on the lake's surface.

The shadows created by strong directional light are compositional objects themselves. They have size and shape which can enhance (or detract from) your main subject. Learning to see

> "... choose the time of day or the season best suited for the landscape scene ..."

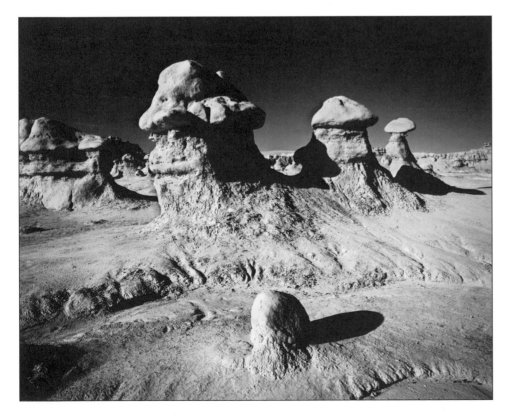

Strong side lighting from the left accentuates the rich texture of these formations. Long shadows emphasize the separation among the objects, as well as the overall depth in the scene. The contrast between their light and dark sides increases their three-dimensional form and the scene's overall dynamic mood.

"Learning to see light ... is the most important skill you will develop as a photographer."

shadows as integral compositional elements is important for creating well-balanced landscapes in strong directional light.

Direct light also creates bright highlights, further expanding the tonal range of the scene. These highlights, along with shadows, delineate the edges of objects and emphasize the separation and depth among objects and the background. Finally, direct light (due to the intensity of the light, the shapes of shadows and highlights, and the strong contrast) creates a dynamic, active mood.

Indirect Light

Atmospheric conditions that block the sun from directly hitting the scene cause non-directional, or indirect, lighting. The most common conditions of this type of light are overcast skies, haze, pollution, dust, mist, rain, or snow. Indirect light is diffused, soft, and "flat." It produces scenes with narrower contrast and tonality ranges than does direct light.

Because the light is diffused, objects have weaker shadows and highlights. The majority of the tones in a bright, indirectly lit scene are medium to light grays. The texture of objects is more subdued or smoother. The entire landscape assumes a softer, more tranquil mood. Whereas direct light can produce areas of deep shadows or bright highlights, indirect light casts a smooth, even glow over the entire scene.

A partially overcast sky created the soft, indirect lighting for this scene. Although the contrast range is normal, the dark silt along the stream's bank not only helps to define the visually strong curve but also adds impact to the landscape by increasing the contrast along that curve.

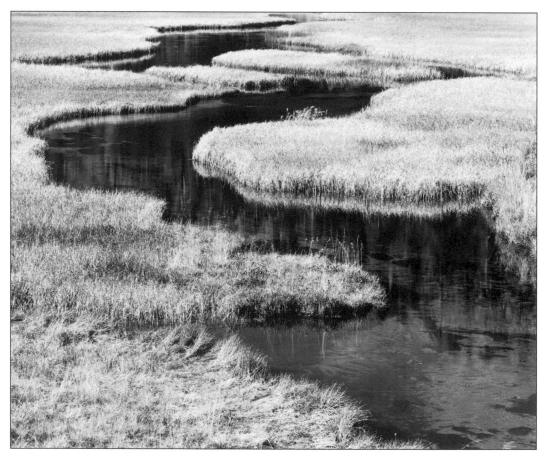

Compositionally, indirect light offers rewards and challenges quite different from those of direct light. First, because the tonal range in diffused light is narrow, the scene can lack the intense contrast that direct light normally provides. A flat-lit scene can often appear dull and uninteresting. Finding areas in the scene that show stronger contrast against the rest of the scene may significantly improve an image.

Also, whereas direct light usually casts a cheerful, energetic, dynamic mood on the landscape, indirect light often portrays feelings more silent, tranquil, dark, somber, questioning, pensive, and static.

Both types of lighting offer the landscape photographer enormous artistic possibilities. Experiment by photographing (or imagining) the same landscapes under different lighting conditions. Directional light with rich shadows, strong contrasts, and well-defined textures may express your feelings about one landscape. Indirect light, on the other hand, with its even light, soft contrast, and narrow tonal range may better express your interpretation of a different landscape.

Both direct and indirect lighting offer technical challenges. In the first, the shadows and highlights are so strong that the scene's total density range is greater than that of most printing papers. Indirect lighting, on the other hand, produces a narrow range of contrast, so the scene may lack visual excitement. In both cases, a combination of filters and Zone System techniques (Sections 4.2 and 4.3, respectively) allows you to control the tonal range and final contrast in the scene. Sometimes, you may want to retain the actual tonal range and overall contrast of the scene. At other times, you may want to expand, compress, or shift the tonal and contrast ranges to represent more clearly your personal vision of the scene.

> "Both direct and indirect lighting offer technical challenges."

Section 3.13
MOTION

The representation of motion can sometimes be a strong compositional element. For example, using a high shutter speed may cause a river to appear static and lifeless. When water is flowing, a viewer expects it to be out of focus and a smooth blend of tones rather than sharply-focused texture. Capturing the river using a slow shutter speed will exaggerate the motion, the blur, and the smooth texture – a representation quite different from reality. Likewise, a flurry of snow may appear softer when photographed using a slow shutter speed.

Sometimes blurred objects increase the compositional strength and mood of the subject. Other objects, if blurry, can attract and hold the eye, possibly distracting from the focal point of the scene. As an example, suppose you are photographing a

"... the mood you want to portray should determine the right amount of blur."

row of trees leading the viewer's eye to a distant mountain range. A strong wind causes the foreground trees to be out of focus. The viewer's eye would concentrate on these blurred trees and cause them to be the dominant element. As with every aspect of composition, no rules exist. You have the artistic and technical freedom to stop all movement completely or to blur some elements in the scene.

Blurring an object only slightly may appear to the viewer as a technical error rather than an intentional, compositional device. Therefore, be sure to blur the river, waterfall, or snow flurry enough to make your intent clear. Conversely, setting the shutter speed too slow may result in a formless, indistinguishable smear of grays. Therefore, the object itself, the other elements in the scene, the lighting, and the mood you want to portray should determine the right amount of blur. Usually, taking several photographs at different shutter speeds increases the likelihood of having at least one image with the amount of blur you desire.

Section 3.14
FOCUS AND DEPTH OF FIELD

Just as you can intentionally blur objects to express motion by using a slow shutter speed, you can control which objects in the scene are in sharp focus and which are not. The amount of the scene in sharp focus from front to back is called the depth of field. This concept is important both compositionally and technically to all photographers.

The eye can focus on a foreground object, a mid-ground object, or a background object – but not at the same time. However, because the eye refocuses at any distance almost instantaneously, an infinite depth of field seems very natural. The camera lens, however, using a very small aperture, can focus sharply on the entire range of vision, so every object in most landscape photographs is in sharp focus.

For close-up photographs, focusing sharply on a single object and throwing the foreground and background out of focus help to direct the viewer's attention to your main subject. A close-up of a flower or a rock, for example, may appear stronger if any distracting elements in the foreground or background are out of focus.

Therefore, blurring can impart a feeling of motion or direct the viewer's attention away from distracting objects and toward your main subject. Although most landscapes appear stunning with every object in sharp focus, your choice to blur some portion of the scene must be a personal one, based on all the compositional elements in the scene.

Section 3.15
DESIGN: VISUAL DOMINANCE

In order to analyze and improve the design of landscape compositions, a photographer should understand how to divide (physically and psychologically) the visual space of the frame. The concept in this division is the dominance of objects within the frame.

Without careful design, what you hope the viewer will see and what the viewer actually sees may be quite different. Your main goal, of course, is that the viewer's eye will immediately see and concentrate on your intended focal point (dominant or active areas) rather than on supportive (or subdominant) areas.

Consider the example of a large foreground rock partially buried in the sand. Both the rock and the sand are light gray. The background is a row of dark trees against a light sky. Even though the main subject is the large rock, most viewers will immediately focus on the dark trees because of their enormous contrast difference. These trees will continue to pull and hold the viewer's attention. The rock that you had wanted to be dominant is now only a supportive element due to its lack of contrast against the sand.

In a similar shift of visual dominance and sub-dominance, imagine a scene with a dark rock and a partially overcast sky. The background trees are medium- to dark-gray, but a ray of sunlight illuminates them. These background trees again take a dominant role due to the lighting. What you intended to be the background has shifted to be the more important focus of the scene. This topic of shift in viewer focus and relative visual importance of the foreground or background is called Figure/Ground (or positive/negative spaces). Figure represents what the viewer interprets as the principal, dominant center of attention in the scene. Ground represents what the viewer sees as the "background," that is, those elements that support the main theme.

Notice that because Figure and Ground represent the viewer's interpretation, they are subjective and vary from one person to the next. If the viewer interprets some or all of the Figure attributes as belonging to the Ground objects, the relationship of these spaces will reverse. The viewer will then focus on different objects and interpret the photograph differently than you had planned.

Although they serve different purposes, both Figure and Ground are equally important. In a well-designed landscape, they complement with (not compete against) each other. In fact, the relationship of Figure and Ground often defines the success or failure of most photographs.

To strengthen your compositions, carefully study the relationship of the Figure to the Ground. Determine whether most viewers will see your dominant focal point as Figure. Analyze the

> "... a photographer should understand how to divide ... the visual space of the frame."

Figure
• Closer to viewer
• Sharper focus
• Requires less physical space
• Has definite size, shape, and texture
• Acts as thematic or visual focus based on object and overall lighting, tonality, contrast, focus, and position

Ground
• Farther away
• Softer focus
• Requires more physical space
• Less pronounced size, shape, and texture
• Acts as supportive to Figure

tonalities, contrast, lighting, focus, and position of the objects in the Figure and Ground to determine if they work together to separate the space into a clearly defined Figure/Ground relationship. If so, you have achieved the first step of design: controlling the visual dominance. The next step is to understand the weight and balance of objects in the scene.

Section 3.16
DESIGN: WEIGHT, BALANCE AND SYMMETRY
Weight

Just as every object in the landscape has a physical weight, every object also has a visual weight. However, whereas the physical weight is measurable and constant, the visual weight is subjective. It depends primarily on the contrast, lighting, focus, size, and position of other objects in the frame. Although this weight is subjective, a viewer will usually interpret light tonalities and wide, open spaces as "light." Conversely, a viewer will most often interpret dark, solid objects as "heavy."

As an experiment, look at several dozen landscape photographs. Determine if the scene appears heavier on the left or on

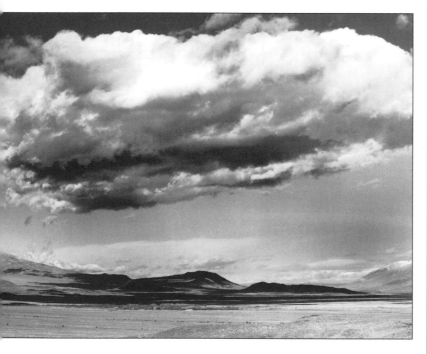
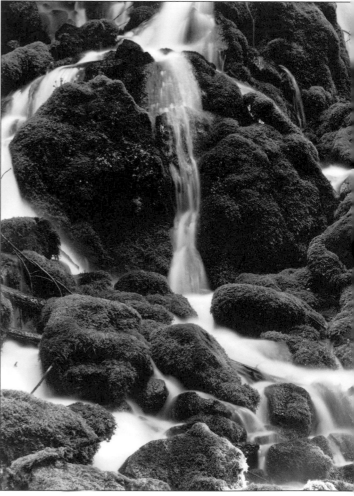

The light-gray clouds, low mountain range, low horizon, wide meadow, and horizontal orientation give the image on the left a light visual weight. The image on the right, however, with its dark rocks, high contrast, lack of a horizon, and vertical orientation is visually much heavier. Controlling these multiple compositional elements allows you to control the visual weight of the overall scene.

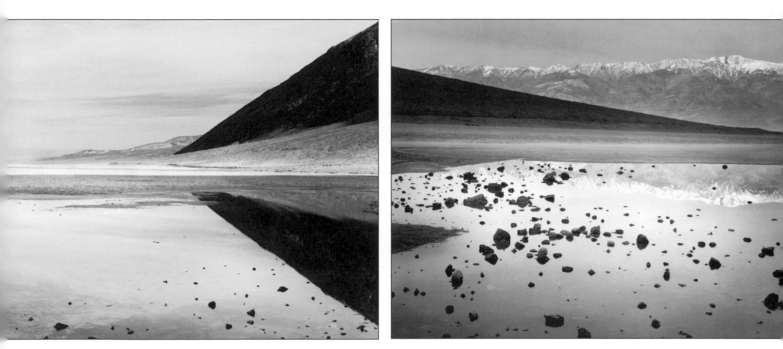

the right, or on the top or the bottom. Also, determine the scene's overall weight – light, medium, or heavy. Now show these same photos to others. Even though visual weight is psychological and subjective, most people will rate these photos similarly with respect to visual weight. This consistency allows you to predict (and even control) the viewer's response.

Balance

The subjective weight of individual objects and of a scene as a whole directly influences the viewer's perception of balance. If the landscape scene within the frame appears visually heavier on either the right or left, the photograph is unbalanced. As an artist, you have complete freedom to choose whether the scene is entirely balanced, entirely unbalanced, or somewhere in between.

An unbalanced landscape can create a tense, dynamic, restless, or suspenseful mood. In fact, the drama of many landscapes comes from the unbalanced design of the natural landscape. Most viewers, however, will interpret an unbalanced scene as tilting or compositionally "empty" in the light side. Most people have an instinctive urge to straighten a picture on the wall. To see it hanging crooked is fascinating yet disturbing.

Symmetry

A composition is symmetrical when the left half of the scene is identical (or nearly identical) to the right half. For example, a large oak tree, centered left-to-right in the frame would create a nearly symmetrical composition. If that same tree occupied more of the left or right side of the frame, the composition would be asymmetrical.

The mountain and its reflection form a dark, massive triangle in the right half of the frame of the left image. Some viewers may like the extremely restless, dynamic, unbalanced mood. Most viewers, however, are disturbed by such strong imbalance. The image on the right, using a different viewpoint, balances the various weights within the scene to create a more balanced image. Neither of these photographs is necessarily stronger compositionally than the other. They each simply portray a different perception of balance.

"... a symmetrical scene offers nearly perfect balance."

The nearly perfect left-right symmetry of these canyon walls presents a balanced, symmetrical scene. Note how the converging lines of the canyon walls and pathway, as well as the diminishing textures and tonalities in the distance, increase the scene's three-dimensional depth.

Because of its left-to-right mirrored distribution of objects, a symmetrical scene offers nearly perfect balance. However, some viewers regard exact symmetry as very static, motionless, stagnant, and even boring. Others enjoy the stability, tranquility, and spatial equality of symmetrical art.

The choice of whether or not to balance a scene symmetrically should be a personal one. The subject itself, the supporting objects, the Figure/Ground relationship, the lighting, the contrast (and most importantly, the thematic statement you wish to make) should determine the degree of symmetry you use for any particular scene.

Asymmetrical Balance

The most flexible, dynamic, and common method of balancing a landscape is to create an asymmetrical arrangement of objects, lines, lighting, contrast, and space whose visual weight is balanced left-to-right.

As an example, by itself, a large, medium-light tree on the left side of the frame appears unbalanced. A group of smaller but darker rocks or bushes in the right foreground would create

Several straight and curved lines lead the eye directly to the asymmetrically placed rock, which serves as a strong dominant element. The large area of light gray, the rock, and the vertical line running from the rock to the camera balance the heavy dark area. Creating asymmetrically, balanced landscape images requires careful analysis of all elements in the scene.

The asymmetry and contrasts of tonality and shapes creates a visually dynamic, interesting view of the distant mountain. The strong tonal contrast and textural "weight" of the mountain balances the smooth-textured foreground rock. Note how strong side lighting creates triangular shadows on the mountain which reinforce the triangular shape of the mountain itself.

sufficient visual weight to balance the scene. Very often, light or contrast alone can counter balance objects. Similarly, lines can create balance or imbalance.

Balancing a scene asymmetrically, then, is the art of arranging and contrasting the scene's elements so that the left and right halves of the photograph have approximately the same weight.

"... every element in the composition combines to determine the subjective balance of the scene ..."

Because asymmetry is impossible without symmetry, and imbalance impossible without balance, most excellent compositions use an artistic interplay among them. One complements and strengthens the other.

Your choice of how much symmetry and balance to use will contribute to a landscape composition's overall mood and interpretation by the viewer. Because every element in the composition combines to determine the subjective balance of the scene, the number of ways to compose a landscape is almost limitless.

Section 3.17
DESIGN: DIVISION OF THE FRAME

If a visually heavy object is very far left or right, the scene appears visually heavy on one side, or unbalanced. On the other hand, if the main focal weight of the landscape is centered or nearly centered from left-to-right, the scene may appear too static. Both of these positions are valid artistically for some subjects in order to portray a certain feeling. Most landscapes, however, benefit by having objects positioned somewhere between these two extremes. Where is the "optimal" placement of the main focal weight within the frame in order to achieve dynamic, asymmetrical balance?

The most commonly used and commonly taught method of dynamically dividing the frame is the Rule of Thirds. The method is simple. Divide the frame into thirds, both horizontally and vertically, creating four lines and four intersections. Now place the main subject in the landscape on any one of these intersections. If the landscape has a single horizontal or vertical line, such as a natural horizon or a single tree trunk, position it at one of the two horizontal or two vertical lines. Finally, place one or more visually lighter subordinate elements at a diagonally opposite intersection to balance the scene.

For example, the first image in Asymmetrical Balance (top image, page 73) demonstrates this method. The rock lies on one of these intersections. The vertical impression in the rock that runs from the rock to the camera lies along one of these division lines. Finally, where the light and dark areas meet on the right edge of the frame is at another division line.

This method should be a loose guideline only – not a rule. In most cases, using it will help to create dynamic, balanced compositions that hold the viewer's attention. However, if every landscape you took adhered to this "rule," your portfolio of photographs would be dull and uninteresting. Like every technique in artistic composition, use this method only as a springboard for your own creative organization of the visual frame.

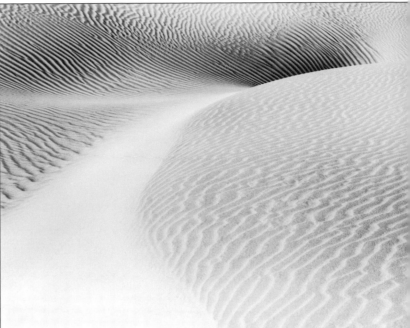

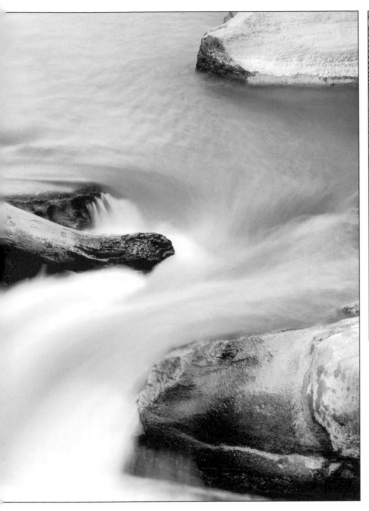

By positioning the camera so that the two rocks, the log, and the swirls of water fall close to the Rule of Thirds intersections, the photograph on the left achieves visual balance. Similarly, in the image on the right, the path curves and converges near two diagonally opposite intersections. This placement assures a very dynamic, asymmetrical balance.

Section 3.18

DESIGN: SIMPLICITY AND COMPLEXITY

An important question facing the landscape photographer is how much or how little detail the scene should contain. Too many texts on landscape composition suggest that absolute simplicity (almost minimalism) is the only artistically valid approach. However, landscapes are naturally complex. Moreover, their intricate design of shapes, lines, and textures creates a landscape's beauty and impact.

The first step in creating an excellent landscape composition is to define your point of view, central theme, and overall mood. Regardless of the level of complexity in a landscape, if your purpose is not absolutely clear to the viewer, the photograph will fail. Once you have defined the singular viewpoint you want to share with the viewer, the "right" amount of detail is easy. Include only enough information to make your point – no less but no more.

Too many extraneous compositional elements can confuse the viewer and detract from (or even completely hide) your intended point of view. Without any clear focal point, the viewer can become frustrated and uninterested. In other forms of pho-

"Unnecessary complexity not only bewilders the viewer but also leads to thematic ambiguity ..."

tography, the focal point is clear to the viewer. For example, in portrait, architectural, or advertising photography, the theme is usually evident. However, the dominant subject in a vast landscape is often less clear.

When the viewer sees richly textured rocks and plants in the foreground, streaks of light through broken clouds and a craggy mountain range in the background, what is the main point? Where should the viewer focus? What is important and what is not? The landscape photographer's challenge is to capture the mood of the scene yet create a well-defined focal point. Unnecessary complexity not only bewilders the viewer but also leads to thematic ambiguity of the photograph's purpose. Because they are powerful and unambiguous, simple landscape designs are usually easy to interpret. Beginning photographers can create a clear point of view by eliminating elements that do not directly relate to the theme.

Too little detail, however, can confuse the viewer by eliminating too much of the scene's context. A close-up of a rock, although free of distracting details, may be puzzling because all references to its location, size, and relevance within a larger landscape have been hidden. As a result, although the point of interest is well defined and unambiguous, the resulting scene may lack character and excitement. Simplification for its own sake is superficial and will usually result in a tedious landscape study rather than in an expressive, artistic, and individual representation of the landscape.

Complex landscape designs can capture (even exaggerate) the inherent complex patterns in nature. Sometimes, more than the actual elements in the scene, complexity itself is the photographer's theme. Complexity can often portray dissonance and even confusion. However, whereas an overly complex composition may occasionally express your interpretation of a scene, a more controlled, focused, simpler design will usually result in a stronger composition.

Deciding how simple or how complex a particular landscape should be depends entirely on the compositional elements in the scene and on your personal interpretation. If the viewer can immediately see (and feel) your intended point of view and mood, then you have expressed yourself clearly.

Section 3.19
DESIGN: VISUAL MOVEMENT

Compositionally, visual movement is different from subject motion. Movement is subjective, characterized by a feeling of overall flow and dynamics in a scene. When the viewer's eye and mind moves, interacts, and participates, the landscape has movement. In such a dynamic work, the viewer often traces lines, com-

pares and contrasts shapes, and repeatedly scans the photograph visually, while questioning and organizing the scene mentally. Dynamic scenes often portray feelings of energy, strength, tension, and mystery.

A static scene is just the opposite. The overall subject and theme is very clear – almost transparent. The viewer's eye and mind quietly contemplate and absorb the entire work as a whole without as much visual or mental participation. Static scenes often evoke quiet and relaxed moods.

The viewer's interaction and mental-visual participation with the photograph defines its degree of movement. A scene that depicts physical motion, such as a flowing river or trees bending in the wind, may still be visually static. Conversely, a landscape scene entirely absent of any actual physical motion, such as sand dunes or a mountain range, may depict a great degree of visual movement.

Like all other aspects of composition, the choice of how much visual movement to use should depend entirely on the scenic elements and on your personal objectives. An absolutely quiet, contemplative, static portrayal may perfectly express your view in one scene. An energetic, dynamic scene that requires more visual and mental participation may best represent your interpretation of another scene. The following table offers rough guidelines for elements which help to define the continuum from the most static to the most dynamic landscape compositions.

> "Dynamic scenes often portray feelings of energy, strength, tension, and mystery."

	Static	Dynamic
Movement	Least	Most
Moods	Familiar, calm, weak, stable, permanent	Strange, energetic, strong, unstable temporary
Lines	Horizontal, vertical, soft curves	Diagonal, tight or jagged curves
Lines vs. Shapes	Form-dominated	Line-dominated
Textures	Smooth	Rough
Patterns (repetitions)	Slight (or no) variation Similar contrast and textures	Strong variation Changing contrast and textures
Tonal range	Narrow	Wide
Overall contrast	Low	High
Symmetry & balance	Balanced, symmetrical	Unbalanced, asymmetrical

FIELD TECHNIQUES

The landscape photographer's first step was selecting the ideal focal length and viewpoint to achieve a perfect composition. The next important step is to transfer that image from the viewfinder to the film.

Three important techniques allow you to achieve the perfect negative easily and consistently: focus, filters, and the Zone System method of exposure. Mastering these techniques will advance your landscape images closer and closer toward fine art.

Section 4.1
FOCUS AND DEPTH OF FIELD
Focus

The eye does not have the ability to focus sharply on a very near object and a distant object simultaneously. A high-quality lens, however, does have this capability. Depth of field represents how much distance from foreground to background will be in sharp focus. Most landscape photographers strive to create the widest depth of field in order to have the entire scene (from the nearest foreground object to the farthest background object) in perfect focus. Unfortunately, even the best modern lenses have depth-of-field limitations, so photographers must understand how to control the focus for every scene.

The principal factors affecting how wide or narrow the depth of field is for a particular scene are the aperture, the focal length, the shutter speed, and, for large-format cameras, the movements of the lens and film planes. By decreasing the size of the aperture (increasing the f/stop value), the depth of field increases. For example, setting your f/stop to f/22 would produce a much wider depth of field than would f/4. Also, the shorter the focal length of the lens, the greater the depth of field. A wide-angle lens generally has greater depth of field than a normal lens, which has greater depth of field than a telephoto lens. Finally, on a large-format camera, the photographer can adjust the lens and

"... photographers must understand how to control the focus for every scene."

film planes in order to increase the depth-of-field in many scenes (see Lens-Plane Movements below).

Whereas the aperture, focal length, and lens-plane movements can affect depth of field directly, the shutter speed affects the depth of field indirectly. Every exposure is a certain combination of f/stop and shutter speed. In terms of the actual amount of light hitting the film, many different combinations are equivalent. For example, f/4 @ $^1/_{500}$ second, f/8 @ $^1/_{125}$, and f/16 @ $^1/_{30}$ all produce the same exposure. However, in terms of the depth of field, each of these combinations produces a different result. The first one will freeze the motion of running water and blowing leaves, but the depth of field will be narrow. The last combination, by contrast, will produce the largest depth of field, but moving objects (such as water or leaves) may appear blurred. In one scene, you may want to blur a flowing river to produce a silky band of light and texture. Your shutter speed must be slow, and therefore your depth of field very high. In a different scene, you may want to freeze the motion of blowing leaves and grasses by setting the shutter speed very high. You must compensate, however, by opening the aperture and thereby decreasing the depth of field. The combination of shutter speed and f/stop to achieve the ideal focus and depth of field is usually a compromise. By deciding the shutter speed and depth of field necessary in a particular scene, you can arrive at the best combination.

Focusing Techniques

Many cameras offer autofocusing capabilities. Unfortunately, the camera cannot determine the position of your key elements, nor can it determine what depth of field you want to use. Even though both autofocusing methods (averaging and spot) reduce your setup time, they also limit your control and creativity. In order to achieve the exact focus and depth of field you want (especially in difficult scenes) manual focusing is the ideal method. Large-format cameras lack autofocusing features; therefore, the photographer must look through a magnifying loupe directly on the ground glass to achieve sharp focus. Although this method requires more time than does autofocus, the photographer is usually more critical of the focus in every part of the scene.

In general, the depth of field extends further beyond the point of focus than it does in front of the point of focus. For landscape photography, a good rule of thumb in order to obtain the widest possible depth of field is to focus on that part of the scene approximately $^1/_3$ of the distance from the camera. This guideline is a simplification of the method to determine hyperfocal length. However, if certain foreground objects are critical to your composition, your point of focus may change. Experimentation and experience are the best teachers for mastering the combination of lenses, f/stops, focal lengths, and point of focus.

"The combination of shutter speed and f/stop to achieve the ideal focus and depth of field is usually a compromise."

Lens-Plane Movements

Large-format cameras offer the photographer an additional method of increasing the depth of field. In some landscapes, the left-hand portion of the scene is closer or farther than the right-hand portion. Similarly, the top of the frame is usually closer or farther than the bottom. The lens board can move independently of the film plane. By making these two planes non-parallel, the photographer can increase the depth of field.

For example, suppose that a scene has an interesting cluster of highly textured rocks in the foreground and mountains in the background. Even using a wide-angle lens and a small aperture, the depth of field may be too narrow to capture both the foreground and background in perfect focus. By tilting the lens board, you will increase the overall depth of field. Many excellent books are available on these large-format camera movements, covering the practical as well as the technical aspects. See Appendix B for a list of recommended books.

The ability of large-format cameras to adjust the lens plane is critical for achieving increased depth of field. Every element in this image is in sharp focus, from the trunk at the camera's base all the way to the most distant trees. This same degree of fine focus would have been difficult or impossible using a small-format or medium-format camera. Compositionally, notice how the reflection of the background forest forms a triangle. A dead tree trunk leads our eye from the camera to the vertex of this triangular reflection. Finally, the trunk and the reflection form two additional triangles that reinforce the forest's triangular shape.

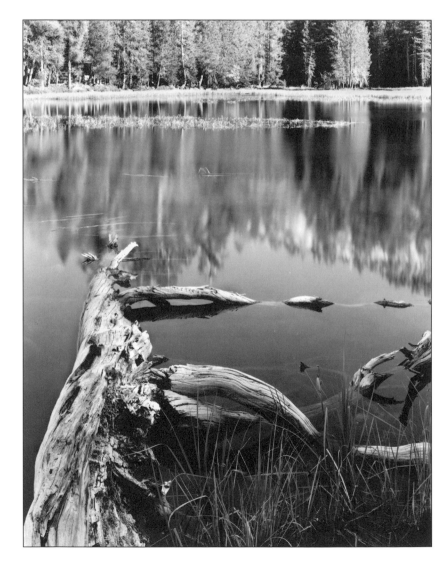

Section 4. 2
FILTERS

An important challenge facing b&w landscape photographers is controlling contrast. Green leaves against a blue sky present a strong contrast in color. However, if the particular shades of green and blue translate to a similar gray, the tonal contrast between these objects is reduced. Similarly, although very light gray clouds against a light blue are discernible, the contrast between them is weakened in b&w photographs.

Photographers need a simple method to lighten or darken any color in the spectrum, thereby lightening or darkening its gray equivalent. The best method for controlling contrast is using filters to intensify certain colors while reducing others.

The Color Spectrum

Pure white light transmits every color in the spectrum. Every object reflects some or all of the light hitting it. Its apparent color is the portion of the entire color spectrum that it reflects. For example, deep red leaves in the fall appear red only because the leaves reflect the majority of red light but absorb most of the other colors in the spectrum. A typical sky on a sunny day reflects not only blue light, but significant amounts of other colors, causing the sky to appear light blue rather than dark blue.

Two simple observations about light are crucial to understanding how filters work. White light contains every color in the spectrum. Therefore, the more colors an object reflects, the lighter it appears. Conversely, the fewer colors the object reflects, the darker it appears. Also, although an object may appear predominately one color, that object is actually reflecting some amount of all the other colors in the spectrum.

How Filters Work

Filters control contrast by allowing light that is the same color as the filter to pass through and by reducing the strength of other colors. A green filter, for example, allows green light waves to pass through but restricts some or all of the blue, red, yellow, and other colors.

A color filter does not increase the amount of any one color passing through and reaching the film. In fact, a filter reduces the intensity of certain colors reaching the film. Because a filter blocks a certain percentage of light waves from hitting the film, the photographer must increase the exposure by that same percentage.

Suppose you are using a light-red filter that requires an increase in exposure of one stop. This filter allows some of the red light reflected from the object to reach the film while blocking a portion of other colors. Because you are doubling the exposure of the red light, the red object will appear darker in the negative

Filter Factor

Most filter manufacturers provide a filter factor – a number that represents the necessary exposure increase. Suppose a filter allows only one-half of the light hitting it to reach the film. To compensate, you must double the exposure time, so the filter factor is 2. This value represents a one-stop increase. Likewise, if only one-fourth of the scene's light passes through the filter, the exposure must be four times longer. The filter factor would be 4, which represents a 2-stop increase in exposure. Remember that decreasing the shutter speed by one speed or opening the aperture (a larger opening but a smaller f/stop number) by one stop will double the exposure.

Meter Systems

Cameras with built-in, through-the-lens meters usually compensate for the filter by increasing the exposure automatically. Therefore, you can usually ignore the filter factor. On the other hand, if you use a hand-held meter to determine your exposure, you need to increase the exposure according to the filter factor.

Filters & the Color Wheel

A color filter will lighten any objects on the same side of the color wheel and darken any colors on the opposite side of the wheel. For example, to darken a blue sky in the final print, you could use a red, orange, yellow, or green filter. A red filter would darken green foliage, whereas a green filter would lighten foliage. This choice allows you to be very flexible and creative with darkening and lightening tones and the overall contrast among objects in your scene.

Determining Exposure for a Filter

To determine the exact exposure increase necessary for a particular filter, take a meter reading through the filter and increase your exposure accordingly. If you have a small-format or medium-format camera with a built-in exposure meter, the camera will meter the filtered scene automatically.

and lighter in the final print. Blue light and green light will be reduced, so those colors will appear darker in the final print. The easiest way to pre-visualize the effect of color filters on black and white prints is by using the color wheel.

Color filters can dramatically alter and enhance landscape photographs. The three most common uses are to darken the sky, to lighten foliage, and to increase overall print contrast by reducing the blue haze of the atmosphere.

Because they can darken certain tones and lighten others, filters allow the photographer to control tonalities and contrast. In one scene, you may want to darken the reddish-brown rocks, lighten the distant green foliage, and darken the sky. A green filter would be ideal. For a more subtle effect, you could use a yellow-green or yellow filter.

Sometimes you may want to reduce the contrast of the scene to achieve a certain mood. Suppose you are photographing pine trees against a light blue-gray sky and snow covers the ground. If you wanted to blend the trees, sky, and snow into almost a wash of white, you could use a blue-green filter. This color would increase blue haze, lighten the sky, and slightly lighten the foliage, bringing the entire scene into a narrow range of contrast. This same level of intricate control would be extremely difficult or impossible to duplicate in the darkroom.

Other Filters

The neutral density and polarizing filters are two additional filters commonly used by landscape photographers. The neutral density filters reduce the amount of light reaching the film and therefore require an increase in exposure, typically 1–3 stops. These filters are useful in extremely bright lit situations for extending the exposure time at small apertures. This increased exposure allows a larger depth of field in combination with blurred motion.

A graduated neutral density filter contains tinting on only one half of it. This filter is useful for reducing the light in half the scene such as a bright sky. Using this filter assures that both the sky and ground are correctly exposed.

Landscape photographers sometimes use polarizing filters for several reasons. First, when the sun is hitting the scene from the side, this filter will darken blue skies and eliminate distant haze. This filter also deepens the tones of most colors and increases contrast by reducing reflections on surfaces such as water, leaves, rocks, and earth. Eliminating these reflections allows the rich textures and saturated colors to show through. Because the polarizing filter is also a neutral density filter, it requires $1^{1}/_{2}$ to 2 stops of additional exposure.

Landscape photographers often use a color filter in addition to a polarizing filter to increase the contrast and deepen existing

Filter Color	Filter Number	Exposure Increase	Effects & Typical Uses in Landscape
Light Yellow	8	0-1	• Light yellow through dark red filters increase the contrast between the sky and clouds
Yellow Green	11	1	• Warm colors (yellow, oranges, and reds) become lighter. Cool colors (blues and greens),
Medium Yellow	12	1	such as the sky and trees, become darker.
Dark Yellow	15	1	• The higher the filter number, the greater its effect.
Medium Orange	16	1	• #15 and #16 accentuate the texture of snow
Light Red	21	1-2	and reduce the effects of haze.
Medium Red	23	1-2	• Medium to dark red turns a blue sky almost
Red	25	2-3	black.
Dark Red	29	2-3	
Green	58	3	• Darkens red rocks, lightens green trees/plants • Darkens sky slightly
Medium Blue	47	1	• Increases effect of mist or fog • Darkens red rocks and trees • Lightens the sky

This table outlines the most common color filters for b&w photography. The darker the color of the filter, the more pronounced its lightening and darkening effects in the final print. Also, as a general rule, the darker the filter's color, the longer the necessary exposure of the film. The exposure increases above will vary depending upon the manufacturer's specifications and the speed (ASA) of the film you are using.

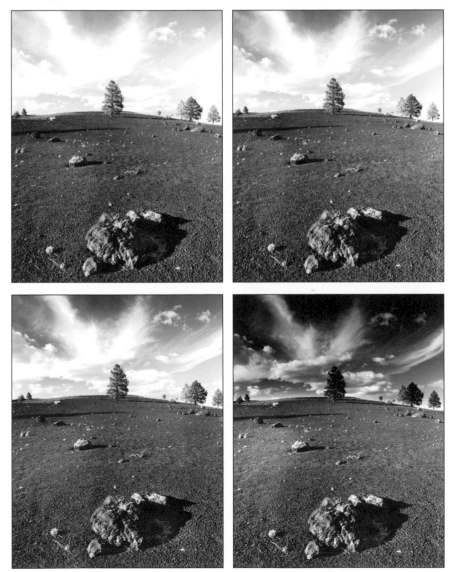

The choice of which filter to use in the field depends on three important factors: the type and intensity of light in the scene, the overall contrast range and the tonal separation of the individual objects within the scene, and the particular mood you want to convey. The top-left photograph shows the scene as it appeared in the actual scene with no filter. Notice the good texture and detail in the shadows. The trees appear to be a "natural" tone for trees in b&w. In the top-right image, a yellow filter helps to increase the delineation between the clouds and the sky. The shadows still retain their detail, and the trees remain the same tonal value. Using an orange filter in the bottom-left image creates a much stronger contrast and delineation between the clouds and the sky. The trees and shadow areas darken considerably and begin to lose their detail. Finally, the bottom-right image uses a red filter plus a polarizing filter to achieve the strongest tonal and contrast change. The sky is almost black now, a common trait when using a deep red filter. The trees and the shadow area of the rock are very dark, and their detail is almost completely lost. To preserve this detail, you would meter for the shadow area with the filters in place (on the camera or in front of the spot meter).

Combining Filters

When combining two filters together for an enhanced effect, simply add their individual exposure increases for the total increase.

Shadows

Shadows are the darkest areas of the scene that show definite texture. The shadow areas may or may not be actual shadows cast from objects.

Highlights

Highlights are the lightest areas of the scene that show definite texture.

Contrast

Contrast is the degree or range between the deep shadow areas and the highlight areas of the subject or the negative.

tones. A polarizing filter plus a medium-yellow (#12) filter, for example, would dramatically darken the sky and reveal minute details in rocks and the earth by eliminating any surface reflections.

Section 4.3
THE ZONE SYSTEM
The Problem

The two most important technical issues facing serious photographers are the correct exposure and the correct film development time. These components are critical for accurately and consistently producing negatives with exactly the "right" contrast range. A "perfect" negative yields deep shadow areas and light highlight areas, both rich with texture, even if the original scene's contrast was too low or too high. Many beginners think that a beautiful print is due primarily to excellent printing technique. Even more important to the final quality, however, is the original exposure and development of the negative. The photographer clearly needs, then, an easy and consistent method to control (and even alter) the contrast range of any landscape scene.

The Solution

In the 1940s, the famous landscape photographer Ansel Adams refined the Zone System to control the exposure and development of film in order to produce negatives with a previsualized contrast range. Using this method, photographers can accurately and consistently decrease or increase the contrast range of a scene.

Hundreds of books and articles on the Zone System are available, covering the beginning to highly technical aspects of this method. However, the fundamental procedure is both easy to understand and easy to implement in the field, allowing you to expand your creative and technical abilities.

Using this relatively simple method will produce accurate and predictable negatives every time you expose the film. Beginners often take five or six exposures at different shutter speed and f/stop settings, hoping that at least one of them will be "right." The Zone System minimizes guesswork in both the exposure and the film development stages, saving you time and money in the field and in the darkroom. Because it is the exposure method of choice for most serious landscape photographers, the Zone System will help to elevate your work, both artistically and technically, into a more professional realm.

The Definitions

The Zone System divides the infinite spectrum of all the tones, from pure black to pure white, into ten equal sections, numbered 0 to IX. The first two zones are completely black with no detail. Zone II is also black with very slight detail and texture. Zones III through VII range from very dark gray to very light gray. All five of these zones are fully textured and detailed, and they represent the tones found in most landscape photographs. Zone V always represents 18% medium gray, the same gray tone that your exposure meter always "sees." Zone VIII is analogous to Zone II in that it has only very slight detail. Finally, Zone IX is pure white, having no detail or texture at all.

Actually, zones higher than Zone IX are possible. Although these areas will print as pure white in the final print, they are sometimes necessary for extended tonal range and contrast flexibility. Advanced books on the Zone System discuss how to use these higher zones. See Appendix B for a list of recommended books.

The first, and perhaps the most important, stage of mastering the Zone System is learning to identify different objects in a landscape with their correct Zone. For example, when photographing a waterfall, you will first need to determine if the dark rock in the foreground is in Zone II or III, and whether the water itself is in Zone VII or VIII. Remember that if an object has rich texture and detail, it should fall somewhere in Zones III to VII.

The Method

The Zone System is a relatively easy, four-step process:

1. **Previsualization** (Where do you want the tones?)
2. **Metering** (What are the actual tones?)
3. **Exposure** (Expose for the shadows.)
4. **Film Development** (Develop for the highlights.)

The first step, Previsualization, determines which areas of the scene should be Zone III (fully textured shadow area) and Zone VII (fully textured highlight area) in the final print. Keep in mind that any object in the scene in Zones 0-II will be black with no detail in the final print. Similarly, any objects Zone VIII or above will be white with no detail in the final print.

For example, suppose that you are photographing the scene on the next page – a canyon with white, sandy deposits on the edge of the rim, and white clouds against a gray sky. In the Previsualization step, you decide that you want the brightest areas of clouds to be the Zone VII highlights with full texture. You also decide that you want the darkest part of the canyon walls to be the Zone III shadow areas.

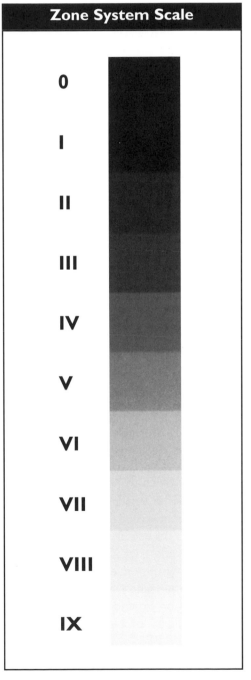

Key Advantages of the Zone System

- Allows photographers to control contrast range
- Relatively easy
- Accurate and consistent
- Flexible to allow creative freedom
- Reduces time and cost
- Widely used by professional landscape photographers

Zone System Scale

0
I
II
III
IV
V
VI
VII
VIII
IX

Maintaining Careful Records

Remembering the technical aspects of every image you take would be impossible. You need to remember the metered values of Zones III and VII and the film type in order to develop your negative. You will need to remember the date and location of the scene for titling and cataloging your image. You will also probably want to remember the time of day, the f/stop, the shutter speed, lens choice, filters added, and any special compositional or technical notes.

The easiest way to remember all this information about each image is to carry a small notebook containing blank **Field Records.** Every time you photograph a scene, take a few minutes to write the above information onto the Field Record. During the film development and darkroom stage, you should also take the time to fill out a **Darkroom Record.** These two records will allow you not only to annotate and analyze your work but also to reproduce any of your images again and again consistently.

See Appendix A for an example of both records. You can photocopy and use these forms, or you can modify them to best suit your needs.

Zone Scale for Meters

On some types of 1° spot meters, you can add a small, circular Zone System scale directly on the exposure dial. This useful scale allows you to find the correct Zone III exposure easily. Using the scale, you can also quickly determine if you need to compress or expand the contrast range using N- or N+ development times.

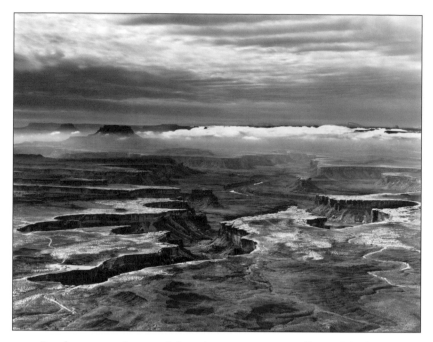

In the second step, Metering, use your reflected light meter (preferably a 1° spot meter) to obtain the actual meter reading in the area(s) that you previsualized as Zone VII. Write down this number. Now meter the area(s) that you previsualized as Zone III. Write down this value also.

Continuing the example, you now take a meter reading of the previsualized Zone VII areas, the clouds and the white sand along the canyon rim. Suppose the meter reports an index value of 11. Write down this value. Now meter the Zone III canyon wall area. Suppose that the meter reports an index value of 8. Again, write down this value.

The third step, Exposure, correctly determines the exposure necessary to place the canyon walls in Zone III so that the shadow areas will be rich in detail and texture in the negative and in the final print. This process is known as exposing for the shadows. Remember that the meter "sees" the canyon walls as a Zone V value, not as Zone III. To compensate for this two-zone difference, you need to decrease the recommended exposure by two stops. The easiest method is to rotate the meter's dial so that this Zone V index number aligns with the Zone III mark. The recommended exposure will now expose the canyon walls at Zone III. If you are using a built-in meter, see the section "Using Built-In Meters" on page 89.

For this example, you simply rotate the meter's dial so that the index value of 8 aligns with the Zone III mark. This change effectively makes Zone III and Zone V have meter readings of 8 and 10, respectively. Now look at the meter's recommended exposure. Suppose that the meter recommends an exposure of f/11 @ $^1/_{125}$ second. Any combination that will give you this same exposure will accurately expose the rock in Zone III. For

example, you could use f/8 @ $^1/_{250}$ or f/16 @ $^1/_{60}$. Remember, however, that you will usually want to choose the smallest aperture in order to maximize the depth of field.

Two Different Exposure Readings?

Why worry about two different exposure meter readings if only one f/stop and shutter speed combination can be set on the camera? The reason is that you will expose the negative for the dark shadow areas (Zone III). Later in the darkroom, you will develop for the highlight areas (Zone VII) by varying the development time of the negative. By writing down these two exposure meter readings on the Field Record (in Appendix A), you will remember which numbers correspond to which negatives when you develop the film.

What the Meter "Sees"

Whenever you take a meter reading of an object (whether that object is black, dark gray, medium gray, light gray, or white) the recommended exposure will be for 18% gray, or Zone V.

Suppose, for example, you want a rock to be in Zone III in the final print. When you meter the rock, you get an exposure recommendation of f/8 @ 1/30 second. The meter, however, is telling you the exposure needed to produce an 18% medium gray, Zone V rock – not the Zone III rock you want. To compensate, you will need to reduce the exposure by two f/stops, by two shutter speeds, or by one of each.

f/stops, Shutter Speeds & Zones

As the camera's aperture becomes smaller (f/5.6, f/8, f/11, etc.) or as the shutter speeds becomes faster (1/30, 1/60, 1/125, etc.), the amount of light hitting the negative is reduced by half. An object in Zone IV has half the light hitting it as an object in Zone V. This relationship allows the photographer to control the Zone of any object. Simply decreasing the shutter speed by one stop or opening the aperture by one stop will move that object into the next higher Zone, effectively lightening the final print. A simple, general rule is:

One Stop = One Zone.

Backup Exposures

The Zone System ensures that you can achieve your previsualized contrast range with a single exposure. However, you may want to take several additional exposures in some situations in order to have a few spares. The cost of a few extra exposures of film in negligible compared to the preparation and effort necessary to obtain that "once in a lifetime" image. Consider making a few additional exposures of a scene to cover the following circumstances. Obviously, the more careful you are, the fewer of these extra exposures you will need to make.

• Rapidly changing weather and lighting conditions increase the likelihood of an incorrect exposure, even when using the Zone System.

• For exposures longer than one second, the reciprocity effect requires exposure times much longer than your meter recommends. Because these exposure increases vary considerably from one type of film to another, bracketing several exposures increases your chances that you will obtain a properly exposed negative.

• If you intentionally want to blur some element in the landscape (water, rain, snow, etc.), determining the most suitable shutter speed is difficult. Bracketing several exposures at different speeds is necessary.

• Loading your own film, especially sheet film, increases the chance of introducing scratches, dust, and pinholes on the film. This dust often appears as a black speck on the final print – sometimes ruining a perfect sky.

• When loading large-format sheet film, you may sometimes load it incorrectly. A few extra exposures are a good idea if you find that "perfect" scene that you do not want to risk losing.

Reciprocity Effect

Normally, f/stops and shutter speeds are interrelated, that is reciprocal. When one increases, the other decreases, thereby maintaining an equivalent exposure of the film. However, as a landscape photographer, your exposures may sometimes be longer than I second. In such a case, the film no longer follows this rule of reciprocity and will require more exposure time than your meter indicates.

Also, these long exposures require a reduction in the film development time in order to maintain a normal contrast range.

The actual increase in exposure and decrease in development time varies considerably from one film and developer to another. Check film and developer specification sheets for their recommended times.

You can use the following table as a rough guideline to the necessary increase in exposure and decrease in development time.

	Meter's Suggested Exposure Time (in seconds)			
	2	4	8	16
Correct Exposure Time (in seconds)	5	10	25	80
Reduced Film Development	0	-5%	-8%	-10%

The final stage in the Zone System method, Film Development, determines the optimal negative development time to insure that the highlight areas that you determined in the Previsualization step are printable and rich in texture. This stage is known as developing for the highlights. Using the meter readings that you obtained in the Metering step, you can now determine the degree of contrast in the original scene, and the proper film development time necessary to produce an optimal negative. Remember, if the exposure on the negative is not sufficient to retain a slight level of detail in the shadow and highlight areas, no amount of darkroom "magic" will create that detail.

As you learn this process, you may want to write down a chart as shown below. As you gain experience and understand the Zone System better, you will probably be able to do this process in your head and then write down just the decreased or increased development time on your Field Record.

First, write the zone numbers from 0 to IX:

Zone:	0	I	II	III	IV	V	VI	VII	VIII	IX

In the Metering step, you obtained a meter reading for your previsualized Zone III. Write this value under Zone III:

Zone:	0	I	II	III	IV	V	VI	VII	VIII	IX
Previsualized:				8						

Fill in the remaining digits, one per zone, from Zone III through Zone VII:

Zone:	0	I	II	III	IV	V	VI	VII	VIII	IX
Previsualized:				8	9	10	11	12		

Now write down under Zone VII the actual meter reading for your previsualized Zone VII area(s) that you determined in the metering step:

Zone:	0	I	II	III	IV	V	VI	VII	VIII	IX
Previsualized:				8	9	10	11	12		
Actual Metered:								11		

Determining whether the negative requires reduced, normal, or increased development time is easy. Simply compare the two numbers under Zone VII above. If they are the same, use Normal development time.

If the actual metered value is greater than the previsualized value, the scene has a wider contrast range than you want. To compensate, you will need to reduce this contrast range by reducing the development time. In the case above, because the num-

bers differ by one, you will use N-1 development time. If the numbers differed by two, you would use N-2 development.

Finally, if the actual metered value is less than the previsualized value (as in the example above), the scene has a narrower contrast range than you previsualized. To compensate, you will need to expand this range by increasing the development time by N+1 or N+2, depending on the difference between the values. In this example, because the actual metered index value (11) is one zone less than the previsualized value (12), you will need to increase the development time of the negative by N+1.

Using Built-in Meters with the Zone System

The explanation above assumes that you are using a hand-held spot meter. Most small-format and some medium-format cameras have a built-in exposure meter that averages the intensity of the light hitting all portions of the lens to arrive at a recommended exposure. These cameras may also offer a center-weighted meter, which bases the recommended exposure primarily on the light hitting the center area of the lens. Finally, some cameras also include a built-in spot meter, which bases the exposure on a very small circular area in the viewfinder. This type of meter most closely mimics the hand-held spot meter, although the hand-held meter is usually more accurate and has a smaller field of view for precisely measuring the light reflected from a particular area in the scene.

Built-in meters indicate the suggested exposure as an f/stop and shutter speed. Unlike the hand-held meters, built-in meters typically do not use index numbers. In order to use the above Zone System method with a built-in meter, you simply need to understand that one index value on the hand-held meter is equivalent to one f/stop or one shutter speed setting. In the Exposure step above, you rotated the meter's dial in order to set the Zone III exposure correctly. Using a built-in meter, you instead reduce the recommended exposure by 2 stops.

In the example above, suppose that when you metered the canyon walls, the camera suggested an exposure of f/11 @ $^1/_{30}$ second. Because this reading actually represents a Zone V tonality rather than Zone III, you need to decrease the exposure by 2 full stops. Any combination of f/stop and shutter speed that will result in a two-stop decrease will effectively expose the canyon walls as Zone III. Using this example, you could use f/11 @ $^1/_{125}$, f/8 @ $^1/_{250}$, or f/16 @ $^1/_{60}$ at Zone III:

N-, N, N+

Film and chemical manufacturers designate normal development time as **N**. Similarly, they denote reduced development times as **N-1, N-2, N-3**, etc., and increased development times as **N+1, N+2, N+3**, etc. The exact temperature and time decrements or increments are listed on film and developing chemical specification sheets. In order to use the Zone System effectively, you need to calculate if the negative for a particular scene requires N-, N, or N+ development.

N-1 and N-2 indicate that the contrast range needs reduced by 1 or 2 stops, respectively. Similarly, N+1 and N+2 indicate that the contrast range needs increased by 1 or 2 stops, respectively.

Zone:	0	I	II	**III**	IV	V	VI	VII	VIII	IX	
Previsualized:				**f/11**							@ $^1/_{125}$ **sec**
or				**f/8**							@ $^1/_{250}$ **sec**
or				**f/16**							@ $^1/_{60}$ **sec**

Now, instead of using index values under Zones III through VII, use stops. Zones III through VII represent 5 zones, the equivalent of 5 stops. Fill in the remaining f/stop and shutter speed combinations, one per zone, from Zone III through Zone VII:

Zone:	0	I	II	**III**	IV	V	VI	**VII**	VIII	IX	
Previsualized:				**f/11**	f/8	f/5.6	f/4	**f/2.8**			@ $^1/_{125}$ **sec**
or				**f/8**	f/5.6	f/4	f/2.8	**f/2**			@ $^1/_{250}$ **sec**
or				**f/16**	f/11	f/8	f/5.6	**f/4**			@ $^1/_{60}$ **sec**

Are You Metering Closely Enough?

If you are using a built-in averaging or center-weighted meter, the closer that your camera is placed to the Zone III and the Zone VII areas, the more accurate the reading will be. Hand-held spot meters avoid this problem by using a very narrow (usually 1°) field of view to determine the necessary exposure.

If your actual meter readings for the previsualized Zone III and the Zone VII areas are fewer than 5 stops apart, you need to increase the contrast range by increasing the development time (N+1, N+2, etc.). If the readings for these two zones are more than 5 zones apart, the scene has a greater-than-normal contrast range. To decrease the overall contrast range, you need to decrease the development time (N-1, N-2, etc.). If the spread between Zone III and Zone VII is exactly 5 stops, develop the film using normal (N) development time.

In the above example, suppose that your original meter reading of the highlight areas (Zone VII) was f/4 @ $^1/_{125}$ second. Because the actual metered exposure (f/4 @ $^1/_{125}$) is less than the previsualized value (f/2.8 @ $^1/_{125}$), the scene has a narrower contrast range than you previsualized. To compensate, you will need to expand this range by increasing the development time by N+1.

Roll Film and the Zone System

Using the entire Zone System is easier for large-format photographers because they can expose and develop each sheet of film independently. No two scenes have exactly the same contrast range. Your first scene may require N-2 development. The next scene may need N+1. The large-format photographer can reduce development for the first scene, increase development for the next scene, and so on.

If, however, you use a small-format or medium-format camera, all your images reside on a single roll of film even though each negative may require different development times. Fortunately, you can still control the contrast for non-normal contrast ranges using several techniques:

1. Changing the camera location, photographing at a different time of day, and waiting for different lighting conditions may help to shift the contrast of the scene into the normal contrast range.

2. Most medium-format cameras have interchangeable film backs. An easy method of using the Zone System with different rolls of film is to use five film backs. Load each

one with the same type of film and label them N-2, N-1, N, N+1, and N+2, respectively. You can then use the N-1 film back for all the N-1 scenes, all the N+2 film back for all the N+2 scenes, etc. Unfortunately, the cost of owning several backs is expensive, and the additional weight could become a concern on long field excursions.

3. If you are using a small-format camera, you can roll your own film not only to save money but also to create rolls with fewer negatives per roll. Changing rolls to accommodate a scene with a different contrast range is less wasteful by having small rolls. If you are using a medium-format camera, you can purchase rolls of film containing either 10 or 20 exposures. Carry the 10-exposure packs to use with the Zone System. You will waste less film if you need to change film for varying contrast situations.

4. As a last resort, you can develop the entire roll using Normal (N) development time. The problem, of course, is that only those scenes that originally had a normal contrast range will contain both shadow and highlight areas rich in texture. Those scenes that originally contained a narrower-than-normal contrast range will appear dull and flat in the final print. Conversely, those scenes that originally contained a wider-than-normal contrast range will exhibit black or white areas with no texture.

Label Your Film!

Whether you use a small or large-format camera, be sure to label the outside of the film with N-2, N-1, N, N+1, or N+2. When you need to develop the negatives, you can easily tell which film gets which development time.

Section Five

DARKROOM TECHNIQUES AND BEYOND

"The darkroom ... allows you to create an image that exactly matches your artistic conception."

The darkroom serves one overall, very important purpose. It allows you to create an image that exactly matches your artistic conception. To some landscape photographers, this vision is a "true," more-or-less literal representation of the original scene. To others, this vision is a composite of two or more high-grain, high-contrast, highly manipulated photographs. Having artistic and technical darkroom skills allows landscape artists to create their final vision.

If you already have access to a darkroom and are fairly experienced, the techniques you have learned will not change for landscape prints. If, however, you currently do not develop your own negatives and prints, you are missing at least half the creative and technical control and rewards of the photographic process. Most cities have one or more photo labs where you can rent space by the hour. These labs offer both casual and professional photographers the opportunity to control the negative and print-making processes without investing in their own darkroom equipment. Also, some colleges offer photography classes and allow you to use their darkrooms. As a last resort, some developing labs will custom develop your prints at a significantly higher price. You can specify reduced or increased negative development times, and you can specify how you want the lab technicians to crop, dodge, burn, bleach, or spot the final print.

The b&w negative of a landscape scene represents a transformation of the original scene. The photographer has already altered, or manipulated, many aspects of the landscape. The color in the actual scene becomes shades of gray in the photograph. Short or long focal length lenses change the "normal" perspective. Very slow or fast shutter speeds either blur or freeze action, again changing what the eye would actually see in the scene. Also, the Zone System and filters allow the photographer to create a contrast and tonal spread different from the actual scene. Finally, some films create extremely high-grain negatives or dramatically alter tonalities, such as infrared films. Each of these intentional

manipulations to the original scene represent increasing degrees of artistic freedom. Rather than represent the landscape exactly as it exists, the photographer has the freedom to manipulate the scene into a unique work of landscape art.

The darkroom is the final process in taking the negative to the finished print. Darkroom processes allow the photographer to refine and enhance the image in order to change its contrast, tonalities, and size. Just as compositional and field techniques allow the photographer to create an individual representation of the original landscape, various darkroom techniques extend the potential to be creative. Whether a photographer prefers to represent the landscape as closely as possible to the actual scene or to alter the print more radically, the final result should be a creative and technically excellent work of art. The degree and type of manipulations are secondary in importance to the final print. If it is creative and technically well-done, if it has impact and drama, and if it conveys a strong sense of purpose, direction, and feeling (hopefully your feeling), the final print will be successful.

Most common darkroom techniques apply to all disciplines of photography, including landscapes, portraiture, and commercial applications. However, landscape photographers use a few techniques perhaps more often for a simple reason: they do not have the luxury of controlling the light on any particular scene. In the final print, some areas may still be too dark or too light, or have a distracting tree limb in the corner. Darkroom processes allow the landscape photographer to solve these problems and create the "perfect" print.

"... darkroom techniques extend the potential to be creative."

Section 5.1
DARKROOM TECHNIQUES
Printing Papers

The type of paper you use will alter the overall mood of your print, sometimes subtly and sometimes dramatically. The choice of which paper to use for a particular landscape should be a personal one. Some photographers use a single type of paper for almost all their work. Others change from one type to another depending on the subject, size, and desired mood of the scene. Papers are available in a wide variety of textures, thicknesses, weights, contrast levels, colors, tonalities, printing speeds, archival qualities, toning properties, and bleaching properties. Generally, a cold-toned, glossy paper works well for dramatic, high-contrast prints with deep blacks and brilliant whites. A warm-toned matte paper may better represent a landscape scene that portrays a softer, quieter feeling. Because these representations are completely subjective, experimentation is the best way for you to decide which papers most closely represent your intended vision of a landscape scene.

	Negative	Final Print
Thin	Light gray to clear →	Dark gray to black
Dense	Dark gray to black →	Medium gray to white

Thin areas of a negative appear light gray to clear. These areas will appear dark gray to black in the final print. Conversely, dense areas of a negative appear dark gray to black. These areas will appear medium gray to white in the final print.

	Under-exposure	Over-exposure
Light and exposure	Not enough light hits film •Light too weak •Aperture too small •Shutter speed too fast	Too much light hits film •Light too bright •Aperture too large •Shutter speed too slow
Appearance of negative	Decreased density (light areas)	Increased density (dark areas)
Appearance of final print	Too dark, increased contrast overall	Too light, reduced contrast overall

Cropping

Even after carefully scrutinizing all elements of the image in the camera's viewfinder, small problems may still appear once you begin printing the final image. For example, an overlooked and distracting object may have unfortunately remained in the frame. If repositioning the camera was difficult, or if the correct focal length lens was not available, your final option would be to crop the image slightly in the darkroom. Cropping the image in the darkroom involves enlargement of the print to exclude these problem areas. These areas, such as protruding branches or out-of-focus objects, will be distracting in the final print.

Unfortunately, any enlargement also increases the grain and reduces sharpness in your final print. Cropping in the darkroom should serve only as a last resort. You should not substitute it for good composition techniques.

Burning and Dodging

Burning and dodging (darkening or lightening specific areas of the print, respectively) are the two most common darkroom techniques for all photographers. Landscape photographers seldom find a scene where the lighting, shadows, and highlights are perfect on every object. Due to an unavoidable shadow, an important foreground rock may be too dark. Slight afternoon flare from the sun may have over-lightened the leaves on an important tree. Careful camera placement, choosing the best time of day, filters (both color and polarizing), and use of the Zone System can help to solve these problems to some degree. However, several areas of the final negative will almost always be too dense or too thin. Sometimes, you may want to lighten or darken a specific area to make it more noticeable. At other times, you may want to lighten or darken an area to subdue it – that is, to blend it into the neighboring elements so the viewer is less likely to notice it. Burning and dodging allow the photographer complete control over the densities of specific areas.

Remember, however, that burning and dodging are limited in their abilities to correct the tonal range of objects. If fine texture in both the shadows and highlights is not present on the negative, no amount of burning or dodging will create this texture. Therefore, creating an almost excellent negative is paramount to achieving an excellent final print. Burning and dodging, as well as all other darkroom techniques, are simply methods to refine and adjust what is already part of the negative.

Reducing, Flashing, and Toning

Landscape photographs often benefit from reducing and flashing. These methods can control contrast problems such as lighter areas in the scene where burning or dodging is difficult. Reducing, also called bleaching, lightens the highlight areas faster

than the darker areas, allowing you to brighten the lightest areas of the print without changing the rich midtones and deep shadow areas. This technique is useful when certain areas of the landscape are too small to dodge without affecting surrounding areas as well. For example, a particular scene may have very small ferns with delicate leaves, or very small rocks with intricate textures. Dodging every leaf on the ferns or dodging every pebble would be tedious or impossible without inadvertently dodging nearby elements in the scene.

Whereas bleaching increases the contrast among the elements in the scene by lightening the brightest areas, flashing reduces the overall contrast. Even though you may have used filters and the Zone System to control the contrast, a scene may still have a contrast range that is too great to print effectively. For example, a scene may have large areas of bright sand, clouds, or water with very slight detail. To decrease the overall brightness, and thereby decrease the print's overall contrast, you can flash specific areas or the entire print.

Bleaching and flashing are techniques that you may want to learn to correct difficult contrast problems in some landscape prints. These processes are exacting because you cannot reverse their effects. If you have bleached a print too long, for example, the print is ruined. Therefore, a light touch and lots of experience are necessary to master these important techniques. Many excellent books are available that cover these and other darkroom techniques. See Appendix B for a list of recommended books.

Finally, toning is a technique that landscape photographers use for several reasons. Whereas bleaching increases contrast by brightening the lighter areas of the print, toning increases the contrast by darkening the deepest areas. Many types of toning chemicals allow you to change the overall color of the tones. For example, using toners, you could transform a b&w scene of wheat fields under an overcast sky into a dark, warm-brown scene with brown-black clouds. In addition, some toners, such as selenium, increase the archival quality of the print (see Materials and Processes, below).

> "... a light touch and lots of experience are necessary to master these important techniques."

Section 5.2
FINISHING THE PRINT

Some photographers enjoy the process of doing their own matting, mounting, and framing not only because it gives them complete control over these processes, but also because these processes (particularly when done well) are an important part of the overall artistic work. You have conceptualized a landscape scene, carefully composed it, technically adjusted it, exposed and developed the negatives using the Zone System, and created the final print in the darkroom using special techniques. Matting,

"... many factors affect a photograph's ability to retain its physical and visual quality ..."

mounting, and framing are the last steps in this rewarding artistic process, allowing you to add a personal touch to every photograph you create.

Archival Materials and Processes

After having taken the time to visualize, compose, develop, and print, the photographer hopes that the final landscape photograph will look the same in fifty or one hundred years as it does today. Unfortunately, many factors affect a photograph's ability to retain its physical and visual quality over the years. First, any developing chemicals remaining on the dried photograph can severely deteriorate the actual paper and the image over time. Also, the air has oxidizing gases and other contaminants which are acidic, causing a breakdown in the quality of the paper and the image.

Archival materials and processes increase the longevity of the print. Just as the landscape you photograph has lasted thousands of years, a landscape photograph has the potential to last hundreds of years in perfect condition. Archival materials and processes will increase the cost of the final print, but they will insure that your landscape prints will last for generations in perfect physical and visual condition. The four principal areas of properly archiving prints are chemical, matte boards, mounting materials, and storage.

CHEMICAL

Final prints should be washed thoroughly according to the paper manufacturer's directions. Improperly washed prints will contain residues of developing chemicals that will cause the paper and tonal quality to deteriorate. Selenium toning makes the final print more resistant to the harsh effects of oxidizing gases and other contaminants in the air, thereby increasing the archival properties of the print. Generally, you should consider the benefits of toning all final exhibition-quality prints in selenium or other archival toners. Although such toning increases the overall processing time and cost, the print will retain its material and tonal quality for decades.

MATTE BOARDS

Although a wide variety of textures and colors for matte boards are available, the simplest approach is usually the best approach. Matte boards for fine-art, landscape photographs are traditionally brilliant white or ivory. Landscape photographers often like to have several inches of border surrounding the print. An overmount (another matte board placed on top of the first matte board) strengthens the visual impact of the print. Using 100% cotton rag museum board will increase the archival quality of the print because this type

of board is free of acids and impurities that can harm or discolor the print over time. The highest-quality boards are buffered; they contain a chemical to raise the pH in order to counteract the natural acidity of the air.

MOUNTING MATERIALS

You can mount the print to the matte board using either double-sided adhesive backing paper, spray adhesives, or dry mounting. The first two methods are easy, fast, and inexpensive; however, these are not archival processes and may, over many years, contribute to the deterioration of the print. The method that most serious photographers use to preserve their photographs is dry mounting. Although this process is more difficult, slower, expensive, and permanent, it increases the archival quality of the print.

STORAGE

Finally, the method you use to store your final negatives and prints can have an enormous impact on their longevity. Never use any plastic sleeves, wraps, or bags that contain PVC (polyvinyl chloride) because it creates gases that can deteriorate negatives and prints. Always use sleeves, wraps, and bags made of polyethylene or polypropylene. To preserve the tonal quality of your negatives and prints, store them in a dark location free of excessive temperature and moisture.

Framing, Signing, and Limited Editions

The most traditional frame for b&w landscapes is a very simple, glossy or matte black frame. Usually, photographers prefer to use regular glass. Non-glare glass weakens the print by softening the overall contrast and sharpness. Your goal should be to have the viewer concentrate on the image that you have taken so much time to perfect, not on the matte board or the frame.

Because of time, space, and money, you may decide to have someone else matte and frame your work. Many excellent framers specialize in fine-art, archival-quality framing materials and techniques.

Some landscape photographers add their signature, usually in pencil, on the matte board in the lower right-hand corner, just below the print. Also, some photographers choose to limit the number of final prints they will produce of a particular scene. For example, you may choose to print a maximum of fifty of your favorite scene. Whether or not you choose to sign or limit your prints is a personal choice. Some of the best landscape photographers do both; some do neither. As the compositional, artistic, and technical quality and demand for your prints increase, signing and limiting the number you print may become more important.

Numbering Photographs

Usually, the photographer writes the number of the print followed by the total number in the series. For example, 7/50 would represent that this photograph is the seventh in a series of fifty prints. This number is usually in pencil in the lower left-hand corner, just below the print.

"... simplicity in framing and in displaying your work usually creates the strongest reaction from the viewer."

Section 5.3
DISPLAYING AND SELLING YOUR PRINTS
Displaying

In a perfect world, your viewers would always stand at the "correct" distance when viewing your finished landscape photographs – not too far away and not too close. At this distance, the viewer is far enough to see the entire print as a single object without having to dart the eyes back and forth in order to construct the scene, yet close enough to see the rich detail, textures, tonalities, and lighting. In most situations, however, you cannot control exactly where your viewers will stand. The best you can do is to estimate the distance from your prints that most viewers will stand and then calculate the ideal print size.

The best lights for displaying your prints are diffused halogen spotlights, which produce evenly distributed, bright light without adding any color. Fluorescent lighting, on the other hand, is very poor because it is weak and can add a greenish tint to the print.

Finally, to heighten the drama of a print, leave lots of empty wall on all sides of it. One or two properly mounted, simply framed, well-lit landscape images on a wall will impact the viewer far more than having a wall crowded with many different landscape prints in all sizes. Just as with composition, simplicity in framing and in displaying your work usually creates the strongest reaction from the viewer.

Once you have created several prints that you consider to be your best landscapes, you may want to display them to the public. Although criticism about your art is initially hard to accept, your landscape photographs will improve both technically and artistically by listening to your viewer's comments. Learning to see your photographs not only through your eyes but through the eyes of others will enhance your awareness and vision.

To ease the initial apprehension of public display, first display your prints in your home and office. Family, friends, and colleagues are often the kindest critics. Once you feel comfortable with displaying your work to this small circle of viewers, consider allowing libraries, offices, museums, stores, restaurants, medical offices, colleges, schools, and photographic retail stores to display your work for free. Usually, you can display a small card under each photograph with its title, the location and date, your name, and contact information such as your telephone number and e-mail address.

After you feel that your art has reached the stage of wide public approval, you may want to consider displaying your prints in large art galleries and in museums. These locations typically require a substantial number of high-quality, consistent, and expertly composed images. In addition, the competition to receive wall space in these locations is fierce. You may need to refine your work for several years to create a portfolio that meets

the rigid requirements of large galleries and museums. With hard work, diligence, perseverance, and some luck, displaying your work in the most prestigious places may become a reality.

Selling

At some point, you may decide to sell your landscape prints. In addition to some of the locations above, a good place to start might be with weekend street fairs and art shows. Many of these venues charge a very small rental space fee, and they often draw large crowds of prospective buyers. Perhaps the most important element to successfully selling your work is wide public recognition of your name. Every person that sees your work with your name increases your chance of selling more prints in the future. Advertising yourself as an artist is as important as advertising the actual landscape photographs.

Consider entering your work in local and regional photographic contests, an excellent way to have your work judged by a group of your peers. You could also use your images on greeting cards, posters, and photographic essays for published articles, advertising brochures, or newsletters.

The Internet is rapidly becoming an extremely popular source for displaying your work and exchanging ideas with other photographers. Dozens of free usenet newsgroups are available to share ideas about almost every topic related to photography. Similarly, the web hosts thousands of user- and company-written pages about photography products, technique, criticism, and art. In addition to being an excellent method for sharing information, the Web is another avenue for selling your landscape photographs.

Although most landscape photographers would enjoy the fame and success of the masters, the real reward of landscape photography should initially and ultimately be the joy you derive from transforming the original landscape into your own creation, and then sharing this vision with others.

Section 5. 4
FURTHER EXPLORATIONS

This book has introduced you to the craft of landscape photography: the selection of equipment, the elusive definition and evaluation of art, the most prevalent compositional techniques, and the important darkroom techniques. With enough time, patience, perseverance, and self-evaluation, you will master these techniques, and your portfolio of excellent prints will increase. Where do you go from here? Many avenues exist for further refining your photographic awareness, technique, and artistic abilities.

The single, most important step to improvement, however, is to keep trying. With perseverance, your landscape art will improve dramatically. Consider the mistakes you make along the

"The single, most important step to improvement, however, is to keep trying."

way as tools for learning. If fine-art landscape photography were simple to master, everyone would be an expert. Although it is a skill that develops gradually, landscape photography will remain educational and exciting for a lifetime.

Visit Museums and Art Galleries

Visiting exhibits of photography at museums and art galleries is an excellent way to view the works of past and present master photographers. Most newspapers and photographic magazines list local and regional exhibits and their dates. In addition, the internet usenet newsgroups and personal photography web pages are an excellent source of information for upcoming exhibit dates and even for reviews of past exhibits.

Attend Lectures

Other photographers often give lectures at local art shows, exhibits, or in the field. Their experiences and suggestions in landscape photography are often quite valuable. Sometimes, the lecturer will be happy to critique some of your prints and offer technical and artistic suggestions for improvement.

Enroll in Classes, Workshops, and Trips

Classes are an excellent way to improve your knowledge about all aspects of photography. Many schools, colleges, camera stores, and commercial darkrooms offer classes, workshops, and field trips for all levels of expertise. Some classes focus primarily on technical improvements, while others concentrate more on artistic choices. Ideally, you should be very well versed in both areas. Classes that require the photographer to participate in the creation, exhibition, and review of each other's prints can be very educational as well as insightful.

Field trips with qualified instructors are perhaps the best way to refine the technical and artistic facets of landscape photography. These trips range from an afternoon to several days, allowing the photographer an isolated, concentrated, and uninterrupted photographic field experience. The opportunity to photograph for many hours in all types of weather and lighting conditions under the supervision of instructors will be invaluable in your long-term growth as a landscape photographer.

Read Books and Magazines

Hundreds of books and magazines on photography are available today, and many focus on landscape photography. Books ranging from the fine-art "coffee table" style to the highly complex technical style cover the gamut of the photographic process. As your interest and experience increase, you will find even more advanced books to help you reach the next plateau of expertise in photography. See Appendix B for a list of some of these books.

"... view the works of past and present master photographers."

Explore the Internet

If you have access to a computer, study the photographs at many of the hundreds of personal Web sites devoted to landscapes by photographers around the world. Also consider creating your own Web page, where you can feature your best works. Allowing your Web visitors to comment on your work will often provide you with invaluable suggestions for improvement. In addition, the Usenet, IRC, and Internet mailing lists are excellent sources of two-way communication for sharing ideas, asking questions, and debating about important issues related to equipment, composition, darkroom techniques, and the critical evaluation of photographic art. Appendix C lists some of the most valuable Internet resources.

Create Portfolios of Specific Themes

Consider photographing an entire series of ten to twenty prints based around a theme. Some obvious themes are regional mountains or rivers, studies of trees or sand dunes, the same location in different seasons, interesting patterns or textures, dramatic cloud formations, or the interplay among the elements of nature and abandoned buildings. Photograph the same scenes under different lighting and weather conditions. Experiment with different filters, shutter speeds, depth of fields, camera positions, and focal lengths. As you experiment, keep careful records about the technical and compositional aspects of each negative. This log will help you to evaluate the prints later. This type of carefully planned and structured photography helps you to focus on a particular type of landscape element, compositional arrangement, or technical aspect. Along the way, you will also be adding to your portfolio of fine prints.

Join a Club or Group

Your local community may have a photography group or club which hosts meetings, classes, and field trips. Your participation is an excellent way to share knowledge, receive constructive criticism about your work from other photographers, and help to critique other's work. These environments are usually very positive because everyone is self-motivated to improve.

Enter a Local Art Show

Most art shows require a preview of your work prior to accepting you. Even if the panel does not accept your work, the review process is another excellent way to receive an unbiased opinion of your photographs. If the panel accepts your landscapes for display in the show, you will receive hundreds of valuable comments from the viewers.

"Also consider creating your own web page, where you can feature your best works."

"Self-critical evaluation is actually the most valuable portion of this experience."

Enter Contests

Many newspapers and magazines host monthly or yearly photographic contests. Some of these adhere to a specific theme, but some of them accept any type of photograph. Submit as many of your best photographs as the contest allows. Even if you don't "win," you will find that the self-critical evaluation process you use to choose and prepare your best prints is actually the most valuable portion of this experience.

Travel

The more you travel through various landscapes, the more creative ideas you will have for turning those scenes into fine-art landscape photographs. Also try to revisit the same scenes at different times during the year. As you advance in your compositional and technical skills, you will find something new every time you visit the same scenic areas.

Section Six
PUTTING IT ALL TOGETHER

Success in landscape photography is dependent upon your ability to see the strengths and weaknesses of every possible viewpoint for a particular scene. The artistic strength of any photograph is a combination of its compositional and technical refinement as well as its uniqueness.

This book has outlined the fundamentals of proven composition, field, and darkroom techniques. As you advance in each of these areas and as you refine your own photographic vision and voice, your landscape photographs will become richer in their ability to express your intended mood or statement.

"Success in landscape photography is dependent upon your ability to see the strengths and weaknesses of every possible viewpoint."

Section 6.1
ANALYSIS OF FIVE IMAGES

The five images in this section embody many of the artistic and technical methods from the previous chapters. To the left of each photograph is a list of the dominant elements from each of these methods. Although analyzing exactly what makes a final print "good" is often complex or even elusive, your images will certainly improve as you couple these composition, field, and darkroom techniques with your own landscape vision.

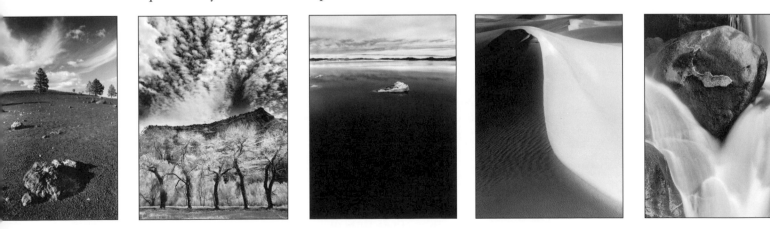

Single Tree and Clouds in Lava Field – Wapakti National Monument, Arizona

Composition Techniques

Shapes	Circular foreground rock contrasts with triangular background tree
Lines	Camera positioned to emphasize V-shaped clouds and horizon lines leading eye to single tree on hill
Texture	Small pebbles throughout contrast with smooth clouds
Viewpoint	Vertical to emphasize depth from rock to tree
Lighting	Strong left sidelight creates rich texture in rock and pebbles; adds shadow for depth
Balance	Left/right, top/bottom
Symmetry	Left/right
Frame Division	Tree and rock on vertical center line emphasizes static, calm mood
Horizon	High to emphasize earthbound feeling and proximity

Field Techniques

Focal Length	Used telephoto to compress foreground and background to bring tree closer; using a wide-angle would have made tree too small
Focus	Focused on foreground rock; used small aperture and lens-plane movements to increase depth of field so that both foreground rock and background tree are in sharp focus
Filters	Used orange filter to enhance sky and cloud separation
Exposure	Took 1° spot meter reading of right side of foreground rock for shadow area (Zone III); took 1° spot meter reading of whitest part of clouds for highlight area (Zone VII)

Darkroom Techniques

Negative Development	Development Normal (N)
Burning	Clouds to darken and delineate against sky; right and left side of horizon to distribute tonality evenly
Dodging	Right side of rock slightly to allow more detail to show
Bleaching	White areas on left of foreground rock and other small rocks; these rocks too small to dodge without affecting other areas
Toning	Selenium for maximum archival quality

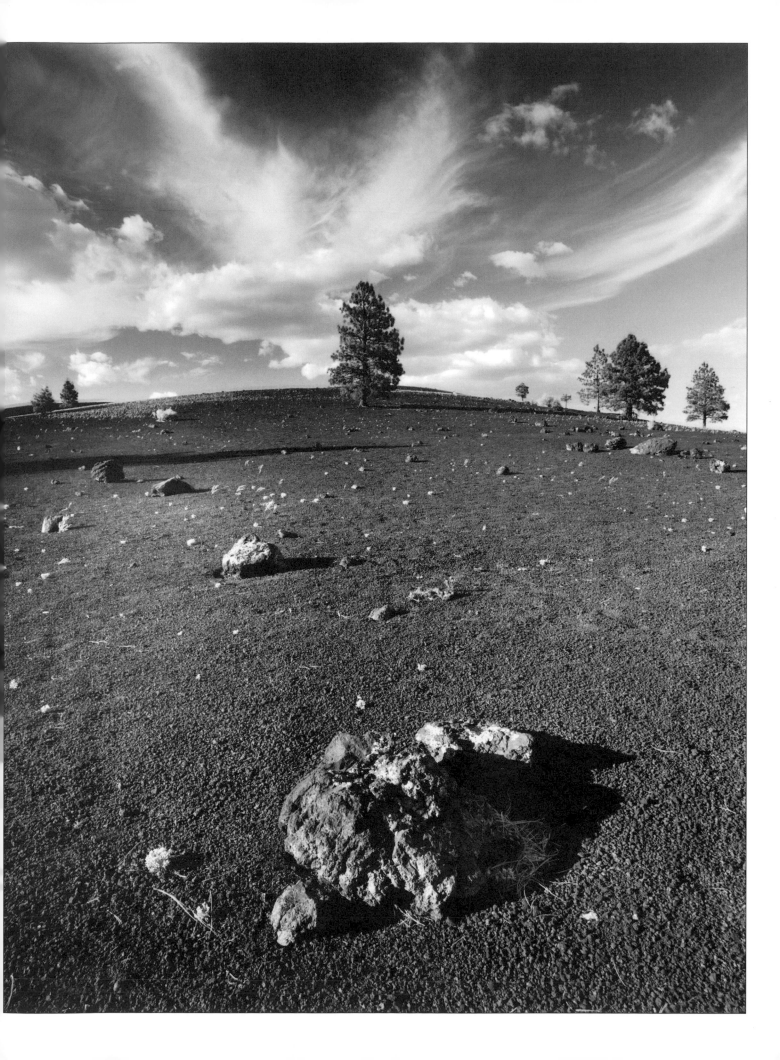

Treeline — Canyon de Chelley, Arizona

Composition Techniques

Lines & Repetition	Vertical tree trunks
Texture	Tree bark and grasses in foreground meadow contrast with smooth clouds
Depth	Trees form separation between foreground and background; helps emphasize depth
Lighting	Strong contrast between light branches of trees and darker rock wall
Balance	Left/right
Symmetry	Left/right
Visual Movement	Five tree trunks act as dominant spots; eye follows trunks up to mountains

Field Techniques

Focal Length	Used slight telephoto to pull mountain closer
Focus	Focused about $^1/_3$ into scene; a wide depth of field not critical because trees so far away from camera
Filters	Used orange filter to enhance contrast between clouds and rock wall
Exposure	Tree trunks are shadow areas (Zone III); white clouds are highlight areas (Zone VII)

Darkroom Techniques

Negative Development	Normal (N)
Burning	Clouds to emphasize texture; also between trees and top of rock wall to emphasize shape and contrast with trees
Dodging	Top of tree branches to emphasize shape and contrast with darker rock wall
Bleaching	Tree trunks to enhance detail; these trunks too narrow to dodge without affecting other areas
Toning	Selenium for maximum archival quality

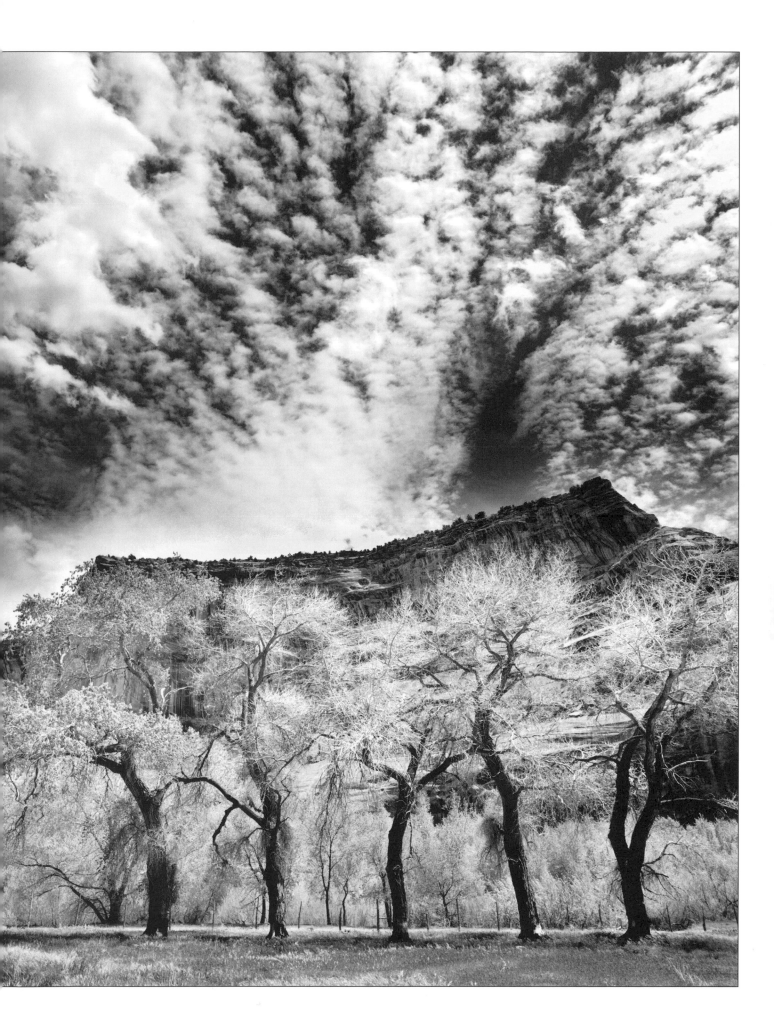

Floating Rock – Mono Lake, California

Composition Techniques

Shapes	Rock acts as dominant spot; holds viewer's attention
Lines	Strong horizontal lines at top leaving borders on both sides suggests infinite view in both directions
Depth	Graduated tones leading from bottom of frame to rock enhances feeling of distance
Viewpoint	Vertical to emphasize distance from camera to rock
Balance	Left/right
Symmetry	Left/right
Frame Division	Rock at $1/3$ line from top of frame
Horizon	High to emphasize earthbound feeling and proximity

Field Techniques

Focal Length	Used normal lens to crop distracting foreground objects
Focus	Focused on foreground rock; used small aperture to maximize depth of field so that both foreground rock and background mountain range are in sharp focus
Exposure	Darkest area is foreground water – set this area at Zone II rather than Zone III in order to expand tonal range and force water at bottom of frame to print as pure black; highlight area (Zone VII) is rock and horizon line

Darkroom Techniques

Negative Development	Normal (N)
Burning	Background mountains; foreground water; right and left sides near rock to even the tonality so both sides the same
Dodging	Foreground rock to accentuate texture and contrast against darker water; highlight areas along the horizon
Bleaching	Bleached rock slightly to lighten small areas of rock that would have been difficult to dodge
Toning	Selenium for maximum archival quality

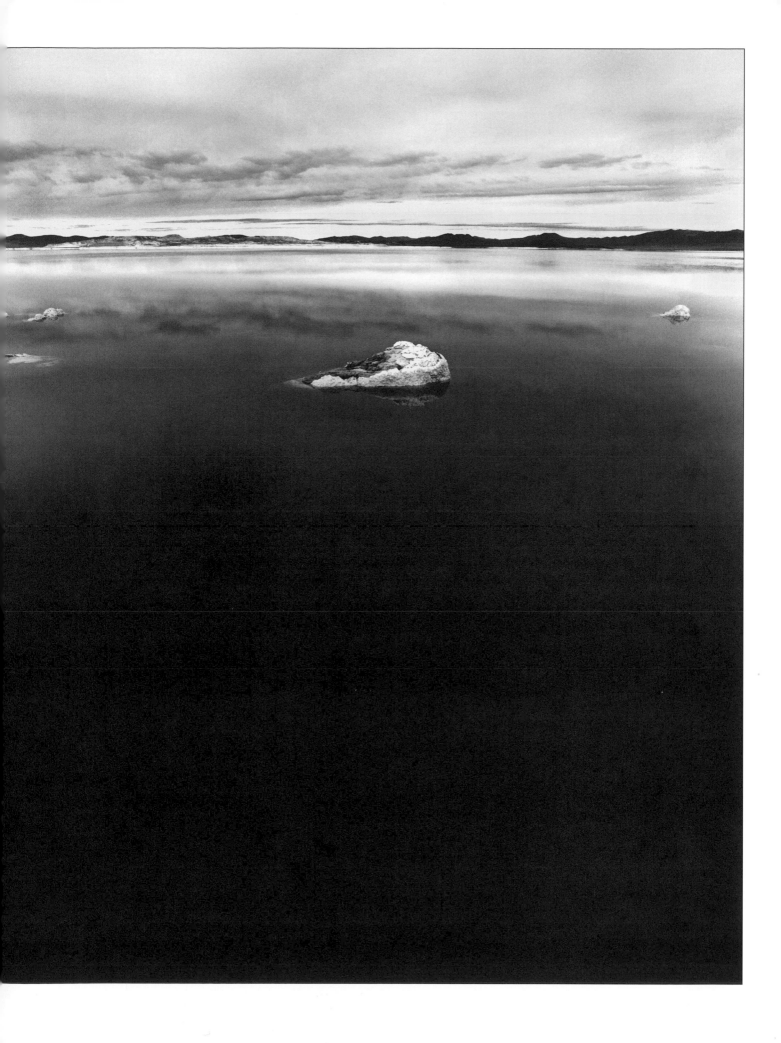

Vertical Sand Dune – Death Valley National Monument, California

Composition Techniques

Lines	Strong dominant curved line; strong supporting irregular background lines add tension, movement, and feeling of infinite continuation of dunes
Viewpoint	Vertical to emphasize curved line running between far distance and viewer
Lighting	Strong right sidelight creates strong contrast between two sides of dune and reveals contrast in texture between smooth right side and richly detailed left side
Balance	Left/right
Symmetry	Asymmetrical
Simplicity	Extremely simple S-curve focal point holds eye while irregular lines at top add movement for movement
Frame Division	Placed S-curve in center of frame to emphasize overall static, calm, isolated mood
Horizon	No horizon exaggerates earthbound feeling and proximity

Field Techniques

Focal Length	Normal lens gave best foreground to background relationship
Focus	Focused about $1/3$ of the way into the scene to ensure maximum depth of field so that foreground part of line would be in sharp focus as well as distant dune lines
Filters	Used yellow to enhance contrast slightly between two sides of dune; yellow also slightly enhances texture on left side of dune
Exposure	Left side of dune is shadow area (Zone III); brightest part of sand is highlight area (Zone VII)

Darkroom Techniques

Negative Development	N+1 to expand contrast range
Cropping	Cropped from horizontal to vertical print to enhance shape of line; could not do this in field due to camera position and available lenses
Burning	Left side of dune to exaggerate contrast with lighter right side; background to keep it subdominant (darker) in tonality
Toning	Selenium for maximum archival quality

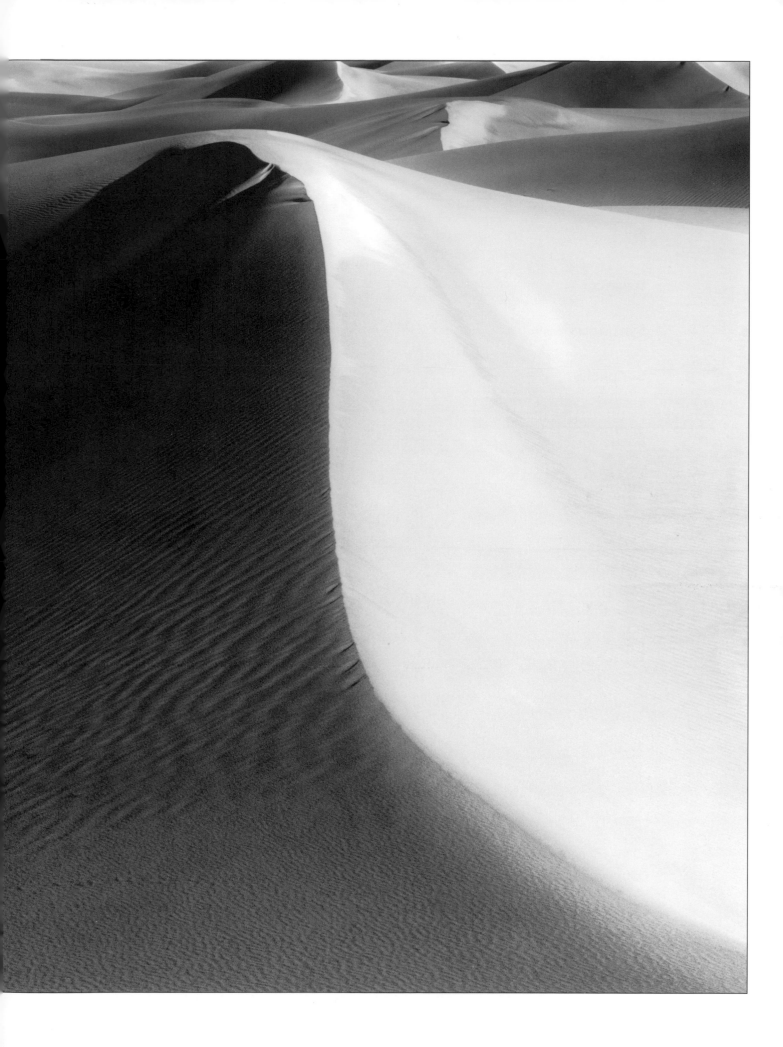

Heart Rock – Yosemite Falls, California

Composition Techniques

Shapes	Dominant spot; supporting V-shape of water framing the bottom of rock
Viewpoint	Vertical to emphasize waterfall and proximity
Motion	Blurred waterfall to create textural contrast between water and rock
Balance	Lower-left dark-gray rock balances with upper-right light-gray water
Symmetry	Left/right
Simplicity	Flat lighting, simple shapes, and soft textures of rock and water create calm, simple image

Field Techniques

Focus	Focused on large rock in center; large depth of field not critical because all elements are in approximately the same plane of focus
Filters	None; could have used green to exaggerate contrast among the different rock surface colors
Exposure	Lightest part of foreground water is highlight area (Zone VII); deepest gray in upper-left corner is shadow area (Zone III)

Darkroom Techniques

Negative Development	Normal (N)
Burning	Rock at lower left to darken as a subdominant element; background to subdue
Dodging	Slightly lighten streaks in water and light portions of rock to enhance texture and contrast against darker portions of rock
Toning	Selenium for maximum archival quality

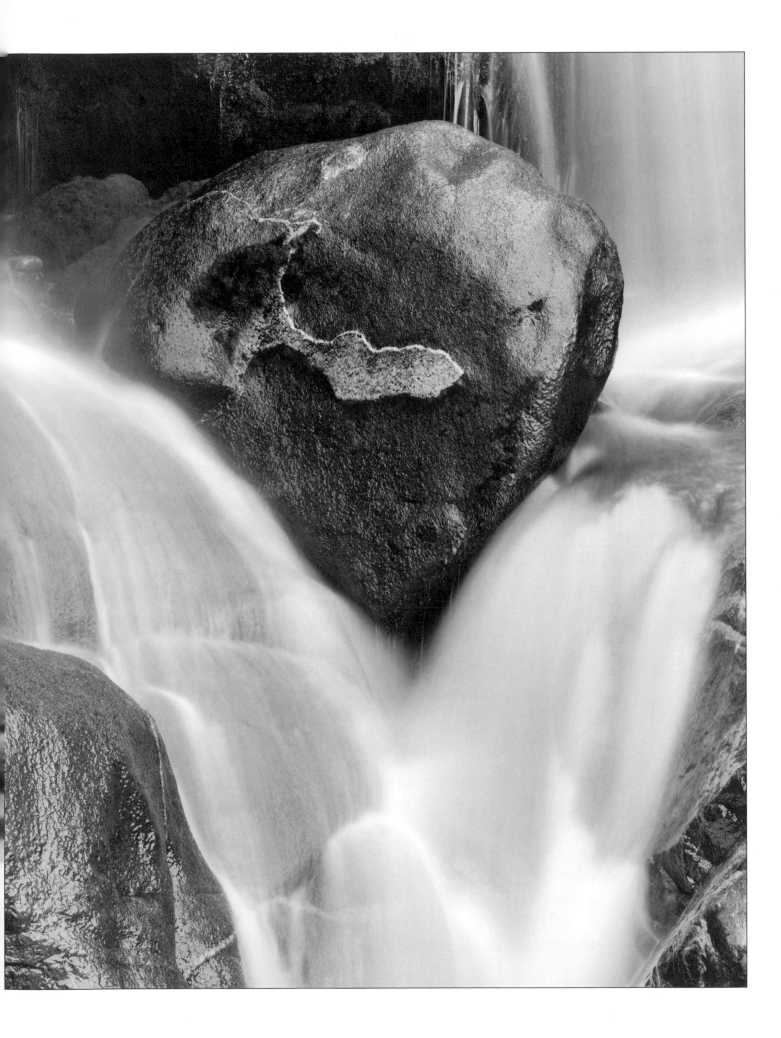

"Most sessions ... require similar types of equipment."

Section 6. 2
CHECKLISTS

Knowing which equipment to take into the field and which equipment to leave behind is, of course, dependent on how many negatives you plan to expose, how many hours and how far you plan to hike, and the type of landscapes you plan to photograph. Most sessions, however, require similar types of equipment. The Equipment Checklist outlines the most important equipment and supplies that you should take for most sessions.

Three additional checklists cover the fundamental artistic and technical elements from the Composition, Field, and Darkroom chapters. As you learn more about landscape photography, these checklists will serve as reminders of the critical techniques. Eventually, the items on these lists will be second nature to you, and you will add many new artistic and technical items of your own that clearly define your work as personal.

Equipment Checklist

Topic	Notes
Camera	
Lenses	Wide angle, normal, and telephoto
Lens shade	One for each lens
Tripod	
Cable release	
Backpack	
Filters	Take at least the minimum set of yellow, orange or red, green, and polarizer
1° spot meter	For large-format photographers, this is necessary; for all others, it is a highly recommended accessory
Film	Usually a minimum of 3–4 rolls of 35mm or medium-format film
Changing bag	This can save the day if the camera jams or you need to change film.
Batteries	Take an extra set for the camera and the 1° spot meter
3"x5" notebook	Containing Field Records and blank sheets
Ballpoint pen and pencil	
Small toolkit and tape	Electrical tape works well for temporary fixes
Windbreaker or jacket	
Food and water	High-energy snacks
Additional Equipment for Large-format Photographers	
Film holders	Usually a minimum of 6–12 film holders (12–24 exposures)
Dark cloth	
Focusing magnifier	

Composition Checklist

Topic	Notes
Visual Elements	• Shapes (circles, squares, rectangles, triangles, irregular) • Lines (horizontal, vertical, diagonal, curved, irregular) • Individual size and the size relative to other shapes and lines • Dominant, supporting, or background? • Distracting? • Repeated? • Combinations? • Continuation off frame? • Similarity or contrast? • Framing other elements? • Tonal contrast of elements? • Texture?
Translating original color 3D scene to b&w 2D image	• Monoptic • b&w • Only one sense (sight) • View restricted by frame
Viewpoint	• Horizontal or vertical orientation? • Camera position • Focal length • Depth cues
Light and contrast	• Type (direct or indirect), direction, and intensity of light • Shadow and highlight placement and intensity • Contrast of main subject to other parts of the scene • Stray reflections or flare? (Use lens shade, hand, or polarizing filter.)
Focus	• Motion (Use slow shutter speed to blur water, etc.) • Depth of field (Use very small aperture to increase depth of field.) • Lens-plane movements (Use on large-format camera to increase depth of field.)
Design	• Visual weight, dominance, Figure/Ground • Balance and symmetry of visual elements, light, and contrast • Division of frame (low, medium, high, or no horizon); Rule of Thirds • Overall simplicity or complexity • Overall visual movement and dynamics

Field Checklist

Topic	Notes
Equipment	• Camera secure on tripod? • Film in camera? • Dark slide removed from sheet film holder (large-format cameras)? • Cable release?
Focus	• Determine desired depth of field (most landscape photographers prefer very small apertures to achieve maximum depth of field; large-format photographers can also adjust the lens plane for increased depth of field). • Decide if you want to blur some portion of the scene (water, rain, snow). If so, use slow shutter speed.
Filters	• Determine if a filter will enhance contrast.
Exposure	• Use Zone System to ensure proper contrast range: predetermine where you want Zones III (shadows) and VII (highlights) to be, meter Zone III, determine exposure, determine proper development time. • Write detailed notes for every photograph on Field Record. • Be sure to increase exposure time for most filters (small-format and medium-format cameras compensate automatically). • Be sure to increase exposure time (due to reciprocity effect) if your exposure is longer than one second.

Darkroom Checklist

Topic	Notes
Negative Development	• Use Field Record to determine proper time (N-2, N-1, N, N+1, or N+2). • Write developer name and time on Darkroom Record. • Wash thoroughly and dry thoroughly. • Store in polyethylene or polypropylene; keep in cool, dry, dark location. • Catalog sheet carefully for future reference.
Orientation, cropping, and enlarging	• Reverse negative's orientation (horizontal / vertical) *only* if necessary. • Crop any unwanted elements *only* if necessary. • Remember that enlarging increases grain size and decreases apparent sharpness. • Write these details on Darkroom Record.
Burning and dodging	• Burn necessary areas to darken. • Dodge necessary areas to lighten. • Write the location and number of seconds for all burn and dodge operations on Darkroom Record.
Reducing and flashing	• Reduce (bleach) if necessary to lighten intricate highlight areas and to increase contrast. • Flash if necessary to darken intricate highlight areas and to reduce contrast. • Carefully watch image during bleaching or flashing; you cannot reverse an error. • Write the bleaching or flashing procedure and time on Darkroom Record.
Finishing the print	• Wash thoroughly. • Tone final image in Selenium (or other archival toner) to achieve maximum archival quality; write toner name, dilution strength, and time on Darkroom Record. • If overall contrast range still too narrow, try using a different grade of paper (or use multi-graded paper). • Use archival-quality matte boards and overmounts; traditional colors for b&w landscapes are brilliant white or ivory. • Use dry mounting for best archival quality. • Wrap final prints in polyethylene or polypropylene; store in cool, dry, dark location.
Framing, signing, and limited editions	• Traditional frames for b&w landscapes are simple, glossy, or matte black with regular glass. • Add signature in pencil, if desired. • Add print number in pencil, if desired.

Section Seven
APPENDICES

Appendix A

This appendix contains the Zone System Field Exposure Record and the Darkroom Printing Record. The first pair is completed to mirror the example in Section 4.3, The Zone System. The second set is blank for you to photocopy and use. Maintaining detailed records of your processes and settings helps you to reproduce any print even years after you first photographed the scene. Establishing a solid cataloging and filing system for images is an important aspect of every fine photographer.

Appendix B

This appendix lists twenty-five excellent books and magazines for further reading. Studying the techniques, theory, and works of others is an important component of refining your own images. However, the two most important elements of artistic growth are experience and personal insight.

Appendix C

This appendix suggests some internet resources you may want to explore. As more and more people are gaining online access worldwide, the Internet is becoming an excellent method to exchange information with other photographers, to view the works of other artists, to display your own images, and to research various artistic and technical aspects of landscape photography. With the enormous amount of free historical and current information about all aspects of photography now available through the above resources, researching and learning about fine-art b&w landscape photography has never been so easy or so much fun. If you are not already familiar with how to access any of these Internet resources, consult your local Internet service provider.

FIELD AND DARKROOM RECORDS

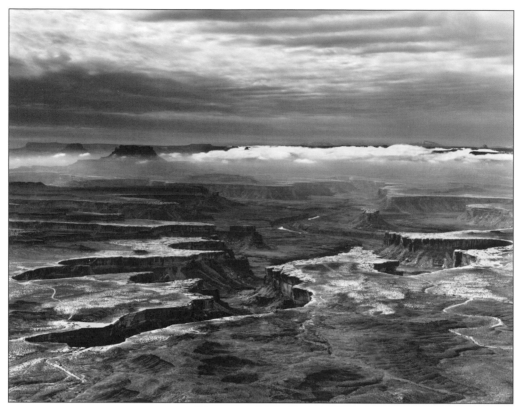

Zone System Field Exposure Record

Title: Winter Fog Over the White Run	Location: Isle in Sky, Canyonlands, Utah
Date: 12/28/97	Exposure#: 1 and 2

Zones	Shadow and Highlight Information	
0		Film: T-MAX 100
I		Lens: 180mm
II		Filter: Orange #16, +1
III	8, shadows in canyon walls	f/stop: f/11
IV		Speed: 1/125 second
V		Development: N+1
VI		Notes: About 9 min in
VII	11, clouds and white sand on rim	TMAX RS; push clouds
VIII		up 1 zone (from
IX		Zone VII)

Darkroom Printing Record

Title: Winter Fog over the White Rim **Location:** Isle in the Sky, Canyonlands, UT

Negative #: 100 **Film Size:** 4x5 **Lens:** 150mm **Enlarger Height:** 31"

Print Size: ___ 8x10 ___ 11x14 _X_ 16x20 ___ 20x24 ___ Other Size: _____

Date Printed: 2/24/98 **Base Exposure f/stop:** f/16 **Base Exposure Time:** 30 sec.

Notes:
Dodge midground canyon walls on left, -5 sec.
Dodge background river slightly, -5 sec.
Dodge canyon walls to retain texture, -7
Dodge foreground depressions, -3 sec.

Notes:
Burn sky above clouds, +15 sec.
Burn right center rock pillar, +3 sec.
 (use small card with hole)

Notes:
Burn corners of sky, +9 sec.
Burn fog over mountains, +15 sec.
 (use card with small hole; keep moving back
 and forth)
Burn left edge of canyon rim (hot spot), +5 sec.
Bleach print – watch clouds and white sand on
 rim of canyon

Paper: Agfa Multigrade Classic, Glossy

Developer: Dektol, 1:4 **Fixer:** Ilford, 1:4

Temperature: 68°F **Time:** 2 min.

Toned? _X_ Yes ___ No **Toner:** Selenium, 1:20 **Time:** 3 min.

Darkroom Printing Record

Title: **Location:**

Negative#: **Film Size:** **Lens:** **Enlarger Height:**

Print Size: ___ **8x10** ___ **11x14** ___ **16x20** ___ **20x24** ___ **Other Size:** _____

Date Printed: **Base Exposure f/stop:** **Base Exposure Time:**

Notes:

Notes:

Notes:

Paper:

Developer: **Fixer:**

Temperature: **Time:**

Toned? ___ **Yes** ___ **No** **Toner:** **Time:**

Zone System Field Exposure Record

Title:	Location:
Date:	Exposure#:

Zones	Shadow and Highlight Information	
0		Film:
I		Lens:
II		Filter:
III		f/stop:
IV		Speed:
V		Development:
VI		Notes:
VII		
VIII		
IX		

Appendix B
RECOMMENDED READING
General Photography

Adams, Ansel. *The New Ansel Adams Photography Series Book 1: The Camera, Book 2: The Negative, Book 3: The Print.* Little, Brown, and Company, 1983

Barnbaum, Bruce. *The Art of Photography: An Approach to Personal Experience.* Kendall Hunt Publishing Company, 1994

Burchfield, Jerry, Mark Jacobs, and Ken Kodrda. *Photography in Focus, 5th Edition.* NTC Publishing Group, 1997

Simmons, Steve. *Large Format Photography.* Amphoto, 1992

Stroebel, Leslie. *View Camera Technique, 5th Edition.* Focal Press, 1986

Zone System

Jones, Chris. *The Practical Zone System: A Simple Guide to Photographic Control, 2nd Edition.* Focal Press, 1994

Woods, John Charles. *The Zone System Craftbook: A Comprehensive Guide to the Zone System of Exposure and Development.* Brown and Benchmark, 1993

Davis, Phil. *Beyond the Zone System, 3rd Edition.* Focal Press, 1988

Darkroom

Anchell, Steve. *The Variable Contrast Printing Manual.* Focal Press, 1997

DeMaio, Dennis and Joe. *The Darkroom Handbook: A Complete Guide to the Best Design, Construction, and Equipment.* Focal Press, 1982

Duren, Lista, and Will McDonald. *Build Your Own Darkroom.* Amherst Media, 1990

Ephraums, Eddie. *Creative Elements of Darkroom Techniques for Landscape Photographers.* Amphoto Books, 1993

Ephraums, Eddie. *Gradient Light: The Art and Craft of Using Variable Contrast Paper.* Working Books Ltd., 1994

Rudman, Tim. *The Photographer's Master Printing Course.* Michelin Beazley, 1994

Marketing

Davis, Harold. *Successful Fine Art Photography: How to Market Your Art Photography.* Images Press, 1992

Fine-Art Photography Books

Barnbaum, Bruce. *Visual Symphony: A Photographic Work in Four Movements.* Alfred van der Marck Editions, 1986

Dusard, Jay. *Open Country.* Gibbs Smith, 1994

McSavaney, Ray. *Explorations: A Photographic Journey.* Findley and Sampson Editions, 1992

Sexton, John. *Quiet Light: Fifteen Years of Photographs.* Bullfinch Press, 1992

Sexton, John. *Listen to the Trees.* Bullfinch Press, 1994

Magazines

Outdoor Photographer *View Camera*
Photo Techniques

Appendix C
INTERNET RESOURCES
Usenet

Usenet newsgroups represent an excellent medium for participating with other photographers worldwide. Most photography newsgroups focus on one topic (such as equipment, artistic, or technical issues for small, medium, or large formats). Travel and cultural newsgroups are also excellent resources to explore before you visit an unfamiliar landscape. Many participants may be able to offer you constructive photographic and travelling tips. The following list represents a few of the almost 60,000 free groups, but new groups are added continually.

GENERAL & TECHNIQUE

rec.arts.fine rec.photo
rec.photo.advanced rec.photo.help
rec.photo.misc cn.bbs.rec.photo
tw.bbs.rec.photo

TECHNIQUE

rec.photo.technique
rec.photo.technique.art
rec.photo.technique.misc
rec.photo.technique.nature
news.admin.photo.technique.misc
news.admin.photo.technique.misc

EQUIPMENT

rec.photo.equipment
rec.photo.equipment.35mm
rec.photo.equipment.medium-format
rec.photo.equipment.large-format
rec.photo.equipment.film+labs
rec.photo.equipment.misc

LANDSCAPES

alt.binaries.pictures.landscapes.amateur

DARKROOM

rec.photo.darkroom

Internet Mailing Lists

Another way to share ideas, questions, and answers about photography is by subscribing to some of the more than 90,000 free internet mailing lists. These mailing lists, as the name implies, are emailed to you automatically every day or week. The Liszt search engine (www.liszt.com) allows you to find and subscribe to lists relating to photography.

Internet Relay Channels

A third method of participating in discussions with other photographers is by using some of the more than 35,000 IRC channels to chat "live" with other photographers around the world. Again, the Liszt search engine will help you to find groups suited to landscape photography.

Web

The fourth (and perhaps the most popular) source of information about landscape photography is the Web. Although most of these sites do not offer the active participation of newsgroups, mailing lists, or IRC channels, they excel in allowing you to access only the information that you want. Most importantly, the web allows you to see the works of other landscape photographers. However, as fast as new Web sites come, others disappear. Any list of photography Web pages may be current today but out-of-date tomorrow. Your best approach for finding landscape photography sites is to use the free search engines on the web. This list represents the most powerful and popular engines currently available.

www.altavista.com www.dejanews.com
www.excite.com www.hotbot.com
www.infoseek.com www.lycos.com
www.metacrawler.com www.webcrawler.com
www.yahoo.com

John Collett Photography

Finally, we hope that you will visit the website of John Collett Photography at <http://www.jcphoto.com> as your first stop in your search for information across the Internet and the web.

GLOSSARY

Archival quality: Traits of a negative or print to retain its physical and visual quality over the years.

Background: Area of the scene that is the most distant from the photographer.

Backlighting: Light that illuminates the subject from the back and shines directly into the camera. Typically used for silhouetting objects.

Bleaching: *See Reducing.*

Bracketing: Taking several photographs of the same scene with each photograph varying slightly by changing the aperture or the shutter speed.

Burning: Darkroom technique for darkening specific areas of the print.

Composition: Organization or controlled arrangement of different elements in the scene to achieve a unified structure.

Contrast: Degree or range between the shadow areas and the highlight areas of the subject or the negative.

Dark cloth: Black cloth draped over the back of a large-format camera in order to eliminate extraneous light and to help focus the image.

Dark hood: Similar to Dark cloth, but hood fits securely around the back of the camera.

Dense negative: Overexposed negative.

Depth of field: Region behind and in front of the point of focus in which everything is in sharp focus. Anything outside this region will be out of focus.

Dodging: Darkroom technique for lightening specific areas of the print.

Dominance: Visually strongest areas in the scene.

Figure: Represents what the viewer interprets as the dominant center of attention in the scene.

Film-plane movements: *See Lens-plane movements.*

Filter factor: Number that represents the necessary exposure increase when using a filter.

Flashing: Darkroom technique that reduces the overall contrast in the print.

Focal length: Directly related to how large or how small the image appears. Lenses fall into three classes of focal lengths: wide-angle, normal, and telephoto.

Focusing loupe: Small magnifier placed directly on the ground glass of a large-format camera that allows the photographer to focus the image precisely.

Focusing magnifier: *See Focusing loupe.*

Foreground: Area of the scene that is the closest to the camera.

Front lighting: Light in front of the subject and behind the photographer.

Grain: Clumps of silver particles on the film created during the exposure and development processes. The effect of grain on the final print is similar to a sandy texture.

Ground: Represents what the viewer interprets as the supporting elements in the scene.

Highlights: Lightest areas of the scene that show definite textures.

Incident light meter: Measures the light falling directly on the subject. This meter is pointed directly at the light source.

Lens-plane movements: Lens-plane and film-plane adjustments on large-format cameras that allow increased depth of field and altered perspective.

Long lens: Another name for a telephoto lens.

Matte board: Board of paper or cotton used to mount photographs.

Medium lens: Another name for a normal lens.

Medium tone: Tonality approximately medium gray, Zone V, or 18% gray.

Midground: Area of the scene that is between the foreground and the background.

Neutral density filter: Reduces the amount of light reaching the film.

Orientation: Vertical or horizontal position of the camera, film, or print.

Overexposure: Too much light reaches the film. The negative appears too dark, and the final print too light.

Perspective: The relative size, shape, distance, and position of objects in a 3D world when transformed onto a 2D surface. Perspective increases our perception of the original scene's depth.

Polarizing filter: Increases contrast by reducing reflections on surfaces such as water, leaves, rocks, and earth.

Previsualization: First step of the Zone System in which the photographer determines which areas of the scene should be the shadow and highlight areas in the final print.

Reciprocity effect: Exposures longer than one second require more exposure time than a light meter indicates and reduced development time.

Reducing: Darkroom technique that lightens the highlight areas faster than the shadow areas allowing the photographer to brighten the lightest areas of the print without changing the midtones and shadow areas.

Reflected light meter: Measures the light bouncing off the subject. This meter is ideal for landscape photography.

Resolution: Ability of a lens or film to reproduce fine detail accurately.

Resolving power: *See Resolution.*

Rule of thirds: Commonly used method of dividing the frame into nine equal squares in order to achieve dynamic composition.

Shadows: Darkest areas of the scene that show definite textures.

Sharpness: Subjective quality of the final negative or print determined by focus, lens quality, depth of field, the degree of apparent motion in an object, grain size, and the resolution of the lens and film.

Short lens: Another name for a wide-angle lens.

Spot: Visually dominant shape.

Thin negative: Underexposed negative.

Toning: Darkroom technique that increases the contrast by darkening the shadow areas. Some toners, such as selenium, increase the archival quality of the print.

Underexposure: Insufficient light reaches the film. The negative appears too light, and the final print too dark.

Zone System: System of exposure that divides the entire spectrum from white to black into ten (or more) zones.

INDEX

Other Books from Amherst Media, Inc.

Infrared Photography Handbook

Laurie White

Covers black and white infrared photography: focus, lenses, film loading, film speed rating, heat sensitivity, batch testing, paper stocks, and filters. Black & white photos illustrate how IR film reacts in portrait, landscape, and architectural photography. $24.95 list, 8½x11, 104p, 50 b&w photos, charts & diagrams, order no. 1419.

Lighting Techniques for Photographers

Norm Kerr

This book teaches you to predict the effects of light in the final image. It covers the interplay of light qualities, as well as color compensation and manipulation of light and shadow. $29.95 list, 8½x11, 120p, 150+ color and b&w photos, index, order no. 1564.

Build Your Own Home Darkroom

Lista Duren & Will McDonald

This classic book shows how to build a high quality, inexpensive darkroom in your basement, spare room, or almost anywhere. Information on: darkroom design, woodworking, tools, and more! $17.95 list, 8½x11, 160p, order no. 1092.

Outdoor and Location Portrait Photography

Jeff Smith

Learn how to work with natural light, select the best locations, and make clients look their best. Step-by-step discussions and helpful illustrations teach you the techniques you need to shoot outdoor portraits like a pro! $29.95 list, 8½x11, 128p, b&w and color photos, index, order no. 1632.

Into Your Darkroom Step-by-Step

Dennis P. Curtin

The ideal beginning darkroom guide. Easy to follow and fully illustrated each step of the way. Information on: equipment you'll need, set-up, making proof sheets and much more! $17.95 list, 8½x11, 90p, hundreds of photos, order no. 1093.

Infrared Landscape Photography

Todd Damiano

Landscapes shot with infrared can become breathtaking and ghostly images. The author analyzes over fifty of his most compelling photographs to teach you the techniques you need to capture landscapes with infrared. $29.95 list, 8½x11, 120p, b&w photos, index, order no. 1636.

Achieving the Ultimate Image

Ernst Wildi

Ernst Wildi shows any photographer how to take world class photos. Features: exposure, metering, the Zone System, composition, evaluating an image, and more! $29.95 list, 8½x11, 128p, 120 b&w and color photos, index, order no. 1628.